Finar
Print

First published in 1991 by
Architecture Design and Technology Press
128 Long Acre
London WC2E 9AN
Fax: 071 240 5771
An imprint of Longman Group UK Limited

Published in the United States of America by
Van Nostrand Reinhold
115 Fifth Avenue
New York, New York 10003

Distributed in Canada by
Nelson Canada
1120 Birchmount Road
Scarborough, Ontario M1K 5G4

ISBN 1 85454 255 9
 0 442 30819 1(USA)

British Library Cataloguing in Publication Data
A CIP record for this book is available from the
British Library

Library of Congress Cataloging-in-Publication
Data is available

16 15 14 13 12 11 10 9 8 7 6 5 4 3 2 1

Series Director: Maritz Vandenberg
Designer: Jonathan Moberly
Photographers: Jo Reid and John Peck,
127 Cadogan Terrace, Old Ford, London E9 5HP

Photographs 3, 4, 5 and 9 on pages 6 and 7 are from
the Architectural Press Photographic Library and the
author thanks librarian Andrew Meade for his patient
help. Photograph 8 on page 6 is by Martin Charles

Linotronic: Alphabet Set, London
Typeset in Neue Helvetica 35, 55, 75
Paper: Japanese white A matt art 157gsm

Printed and bound in Hong Kong

Financial Times
Print Works

London 1988
Architects:
Nicholas Grimshaw
and Partners
Text and drawings:
David Jenkins
Photographs:
Jo Reid and John Peck

Architecture in Detail

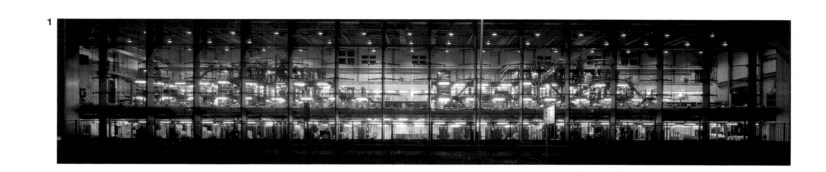

Every evening at 9.30, except Saturdays, in the machine hall of Nicholas Grimshaw's Financial Times print works, the first edition of the following morning's paper goes to press[1]. As they roll off the high-tech presses at a rate of up to 70,000 copies an hour, the papers are collated, folded and immediately despatched by truck to Wales and the North of England and to Heathrow to be flown to Scotland and Ireland, or overseas to reach the FT's remotest readership in places as far afield as Southern Africa, Australia, Malta and Gibraltar.

At 11.15–11.30 pm the second edition appears and is destined for regions closer to home in the Midlands, East Anglia and South Wales. The third edition runs from around 1.00–1.30 am and is driven to four wholesale collection points in the South of England for distribution to 20,000 retail newsagents who will deliver the paper to breakfast tables and news stands in London and the Home Counties. Later editions intended solely for distribution in Central London can run from 3.00 am onwards, allowing the editors to track a developing City story or incorporate important late news such as a bye-election result or foreign financial market movements.

In all, up to 250,000 copies, of up to 56 pages, leave East India Dock House each night. In addition, facsimiles of the pages are transmitted by satellite to contract printers at Roubaix near Lille, Frankfurt, and Bellmawr, New Jersey for the European and US editions, bringing the FT's total daily worldwide circulation up to nearly 300,000 copies.

The FT aims to cover everything of importance and interest to the 'internationally-minded businessman' and is renowned for its accuracy and independence. It exists primarily as a newspaper of record. Editorial reports cover trade and industry, the financial markets, politics, technology, management and marketing techniques, the arts and architecture. It also publishes approximately 250 surveys each year which provide information and comprehensive analyses on particular industries, services, regions and countries.

The history of the FT

The paper first appeared on the streets of the City of London on February 13 1888. Its masthead bore the bold inscription 'Without Fear and Without Favour', and it confidently proclaimed itself to be the friend of the 'honest financier' and the 'respectable broker', and the enemy of the 'unprincipled promoter' and the 'gambling operator'.

It was five years before the FT's owners prudently took advantage of the reduced costs of recycled newsprint and turned it 'pink', a move which immediately distinguished it from its arch-rival the Financial News. The two papers remained in close competition until they were merged in 1945 following the reluctant decision of the FT's proprietor Lord Camrose (who also controlled the Daily Telegraph) to offer his paper to the owners of the Financial News. Camrose anticipated a Labour victory at the 1945 general election and believed that the depressed post-war City would be unable to support two financial dailies.

The principal benefactor of Camrose's pessimism was Financial News Chairman, Brendan Bracken, a larger-than-life personality in the best Fleet Street traditions and reputedly Evelyn Waugh's model for Rex Mottram in Brideshead Revisited. Bracken appointed new editorial staff, revitalized the re-cast FT and gave new impetus to his burgeoning empire.

Bracken House

In 1957, when the paper was bought by Pearsons, new capital was injected into the company and a new headquarters commissioned on a site close to St Paul's in Cannon Street in the heart of the City. 'Bracken House' was a magnificent gesture of corporate confidence, designed by Sir Albert Richardson and built in a combination of red brick and a 'pinkish' sandstone[2]. In spirit it harked back to the great Fleet Street paper palaces of the 1920s and '30s which were built by competing press barons, keen to demonstrate the prosperity of their publications, and eager to outdo each other in the scale and splendour of their surroundings.

The resulting Fleet Street building boom

2

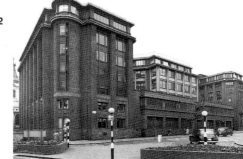

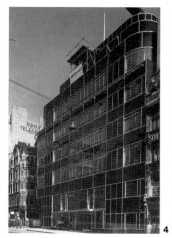

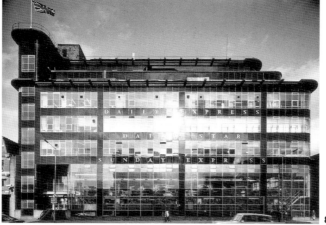

4

8

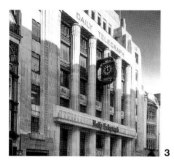

3

climaxed with two of its greatest buildings. Lord Camrose's Daily Telegraph occupied a curiously hybrid Graeco-Deco block designed by Thomas Tait with Elcock and Sutcliffe in 1928[3] while Lord Beaverbrook's Daily Express moved into its pioneering streamlined block three years later in 1931[4]. Designed by Sir Owen Williams with Ellis and Clarke, the building carried a hoarding during its construction boasting that it was 'Britain's most modern building for Britain's most modern newspaper'. Much later it earned the nickname of 'the black Lubianka' because of its black Vitrolite glass facades and underground press hall – a 29ft deep cavernous basement which became oppressively hot and deafeningly noisy when at the dead of night, the presses thundered into action[5].

These were corporate buildings on the American model, each perfectly embodying the aspirations and characteristics of the newspapers they housed; the Telegraph august and slightly pompous, the Express innovative and selfconsciously 'go-ahead'. Bracken House too can be seen as the perfect setting for the FT of the 1950s which propagated an air of sober detachment.

But some contemporary critics were outraged at the way it cut across the prevailing Modernist grain. Sir Nikolaus Pevsner described the building as being 'hopelessly out of touch with the 20th century' after visiting it under construction in 1957 and characterized the attitude of its academic and historicist archi-

tect as 'what was good enough for my grandfather is good enough for me'. It was emphatically the work of a traditionalist and an acute observer of Fleet Street custom: its astronomical clock[6] continued a newspaper convention established by the old Times building in 1872, whose pedimented facade incorporated a huge public clock face before its destruction in World War II. Even now the electronic clock and share index indicator that sit outside the new FT print works gives this tradition a late 20th century twist[7].

Notwithstanding Pevsner's sniffy comments, Bracken House became a popular city landmark (and the first post-war building to be listed) and an acknowledged out-post of Fleet Street, a name that until recently was synonymous with the English newspaper world.

A Fleet Street typology

Fleet Street developed as the home of newspaper publishers and printers from the beginning of the 18th century; the earliest English newspaper, the Daily Courant, being founded in 1702 at an address near Fleet Bridge.

In 1826 Fleet Street's first purpose-designed printing works, the Temple Printing Office, combined offices, a print works and warehousing on a site close to the east gate of the Temple. By placing the editorial staff, compositors and engravers in well-lit rooms on

the upper floors and relegating the actual business of printing to the lower and basement levels it presaged what became, after a rapid expansion in newspaper titles and sales at the end of the 19th century, a familiar Fleet Street typology. The editorial and administrative offices were located in grand blocks on the Fleet Street frontage while the presses were sunk into labyrinthine basements or housed in industrial buildings on the side streets. Only occasionally would one catch sight of the secret nocturnal activity within, through an open hatchway or loading door.

Bracken House, on a site bounded by three broad streets, subverted this familiar model by sandwiching the operations of the St Clement's Press (the printing arm of the company) between two blocks of offices.

Owen Williams had already taken this process a stage further in the northern premises of the Daily Express, 1935–39, which occupied a similarly prominent site in Manchester. In a building which effectively had no 'back' Williams was able to open up the production areas to public view, allowing late-night passers by the compelling spectacle of the ranked presses in action behind the fully-glazed facade[8].

The coming of new technology

But by far the most revolutionary typological change has been brought about by the combined effects of

5

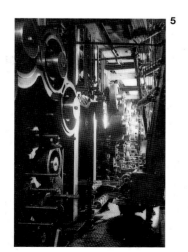

6

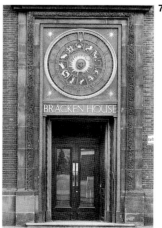

7

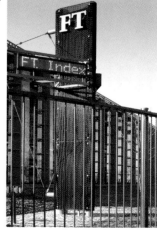

9

the advances in new technology and the breakdown of old-fashioned industrial relations.

Unlike most other industries which have gradually shifted out of town to industrial estates or other designated areas, the press baron's retreat from the city is a very recent trend. Traditionally, journalists have needed to be 'where the action is' and the editorial staff had to be near the compositors and printers on whose skills the old hot-metal process depended[9] – and whose increasingly restrictive practices, overmanning and industrial disputes had begun to make newspaper publishing an unprofitable business. But just as the print workers shot themselves in the foot, new technology gave the industry a shot in the arm by making the physical link between the editorial and printing operations redundant, along with hundreds of print workers.

The exit from Fleet Street

Many publishers sold their valuable city premises and moved out to the enterprise zones of London's Docklands. Editorial staff now tend to be located in speculative office blocks, and the majority of printing takes place in anonymous industrial structures on sites that can be easily serviced by delivery trucks.

In 1986 Rupert Murdoch (the biggest and boldest press 'baron' since Lord Beaverbrook) moved The Times, the Sunday Times, the News of the World and the Sun into a brand new fortress-like printing plant at Wapping.

Subsequently, the move away from Fleet Street gained increasing momentum. Associated Newspapers, publishers of the Daily Mail, moved its printing plant to the Surrey Docks and its editorial staff to Kensington. Telegraph Newspapers went even further and moved their whole operation to the Isle of Dogs. Eventually, the other papers followed, the FT being among the last to desert its old premises in 1988 and the only one to maintain its architectural standards in the process.

Modern requirements

While editorial staff can be moved into almost any available office space – the FT's editorial staff are now housed on the South Bank in a block next to Southwark Bridge – the printing process still requires purpose-designed buildings which, in simple terms, 'clothe' the presses since they are by far the largest physical and capital element of the investment.

The new presses are larger and heavier than those they have replaced; each unit is in effect an independent structure with its own staircases, platforms and access galleries. And the press halls are the new cathedrals of industry[10], reminiscent of the generator room at Battersea Power Station or the turbine deck of a great liner. The new machines are also faster and more technically sensitive, requiring high standards of environmental control including dust filters, air conditioning and humidity regulators since newsprint is highly sensitive to atmospheric moisture and must be kept in a stable condition to allow high-speed running. Advances in technology have led to a greater clarity of printed text, and more faithful reproduction of photographs. And some processes can print black and white, spot colour or full colour pages in a single process.

The new building is commissioned

By the time Nicholas Grimshaw and Partners was appointed in November 1986, the FT had already ordered its two new seven-unit Rockwell Goss Tower Headliner web-offset presses which were due for delivery 12 months later. It had also approached the London Docklands Development Corporation, found a site in the old East India Dock and appointed the Robinson Design Partnership – which has a detailed knowledge of the newspaper world – as press engineers and fitting-out consultants.

To a company that is used to putting a (usually) 48-page newspaper together in an hour and a half and then printing hundreds of thousands of copies in roughly twice that time, speed is a way of life, and the St Clement's Press naturally demanded fast-track design and construction to meet its deadline.

10

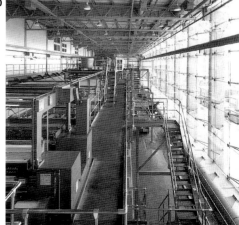

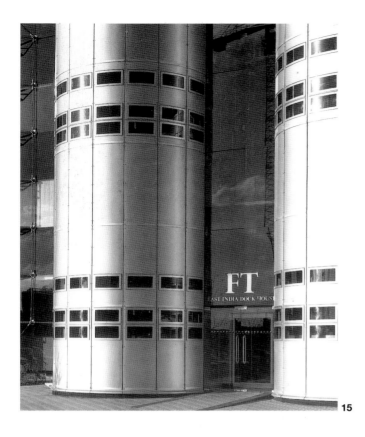

15

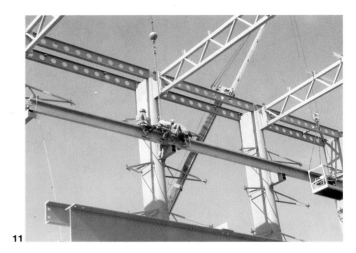

11

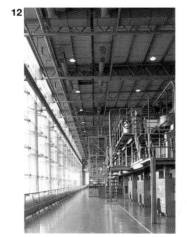

12

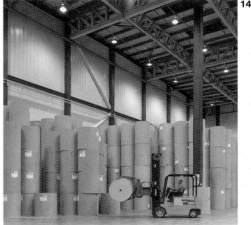

14

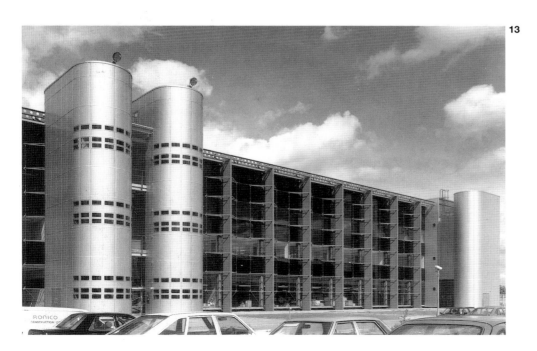

13

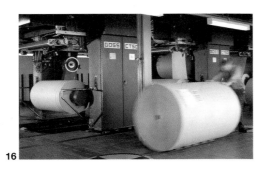

16

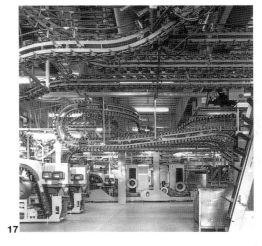

17

The design response

Grimshaw's response was to propose a loose-fit structure with a simple section that divides the bulk of the building's 14,000 sq m into two 18m wide clear-span zones[11] on either side of a 12m wide central 'service' spine. The northern zone, facing the East India Dock Road[12] houses the presses – whose size determined the building volume – and the southern span facing the car park[13], houses the ancillary areas – offices, publishing and composing rooms and a restaurant. At the ends of this principal block are a paper store large enough to contain three weeks' supply of newsprint[14] and a despatch bay; the whole plan being arranged in an asymmetrically-weighted 'dumb-bell' with solid ends and a glazed middle, served by free-standing stair and lift towers which also control the main entry into the building[15].

The flexibility of this arrangement allowed the brief for the ancillary areas to be worked out long after details of the frame and cladding had been finalized.

To avoid complicating the primary portal structure, the southern enclosure was constructed, like that on the north, as a 16m high clear span which was subsequently infilled with an independent secondary steel frame that supports the upper accommodation floors. These floors were then subdivided once the client's detailed requirements became clear.

In simple terms, the division of labour between

press engineer and architect meant that everything inside the building became the responsibility of the Robinson Design Partnership while Grimshaw designed the structure and cladding, but also co-ordinated the installation of services, which include two independent electrical lines to guard against power failure, and a powerful sprinkler system, capable of jetting 1600 cubic metres of water into the paper store within the first 15 minutes of a fire.

The layout of the building reflects the linear printing process exactly, beginning with the incoming rolls of newsprint, each of which weighs 1.75 tonnes. It continues along the ranks of presses, the rolls being manhandled through a system of in-floor conveyors and turntable trolleys and into the individual machines[16]. At the end of this line, the folded papers are carried on an overhead copy conveyor that snakes out of the press hall and through the ground-floor publishing room on its way to the despatch bay[17].

Architecture at the crossroads

The architectural moves were equally simple, but seen in context they have produced a building that by day can be viewed as a coolly detailed enclosure and by night as a startling and brightly lit spectacle as it becomes transparent, revealing newsprint running on massive presses; a diagonal flash of pink darting through the primary painted machines[18].

Like Owen Williams's Manchester Daily Express building which exploits its prominent site by making the daily business of printing into a piece of two dimensional street theatre, the FT print works offers motorists a kind of animated billboard as they sit at traffic lights or speed out of town[19]. Around it the derelict hinterlands of Poplar, the dismal crossing of the traffic laden A13 and the Blackwall Tunnel approach road could double for Gertrude Stein's vision of Oakland USA: when you get there, there just isn't any there there.

But it is a paradoxical place: within a 200 yard radius there is a clutch of major architectural works. To the north, Erno Goldfinger's Rowlett Street housing, 1966–78; to the south, Richard Rogers's new headquarters for Reuters (another Fleet Street emigré); and to the west, Alison and Peter Smithson's Robin Hood Gardens Estate, 1968–72. Further on, the tall obelisk spire of C. Hollis's All Saint's Church soars above the East India Dock Road. To the motorist however, only Nicholas Grimshaw's building provides the appropriate ingredients of 'thereness'. It is an immediate landmark, as distinctive at the eastern entry into London as the Hoover Factory is in the west.

Structural expression

Part of the building's distinction is due to the finely elaborated outboard structure that supports its two

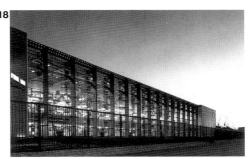

18

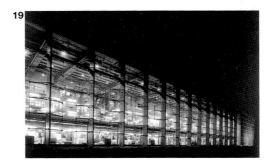

19

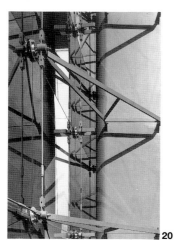

20

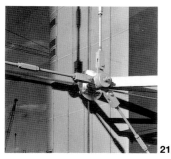

21

24

long glass walls[20]. A concern for structure has become an increasingly important part of the Grimshaw office's work. Some schemes such as the Oxford Ice Rink, 1984, and Sainsbury's Supermarket in Camden Town, 1988, lean overtly on structure for their architectural expression. Grimshaw himself says that 'it's hard to think of a good building of any period where the structure is not at least understandable'. In Grimshaw's own work this understanding combines with a fascination with automotive and aeronautical technology (a high-tech family characteristic that can be traced to the founding Modernists and Futurists) and is followed through to culminate in a meticulous attention to detail.

The FT's specially developed structural and glazing system can be seen as a typical example of the office's working method. It is a 'one-off' developed within a very tight programme that included making a full-size prototype section of an outrigged column with its circular stainless steel connectors or 'dinner plates' that hold the glass in place[21].

The glazing was supplied by Pilkingtons, whose Planar system was originally developed in response to the challenge of Norman Foster's pioneering suspended glass curtain wall at Willis Faber Dumas, 1971–75. However, unlike Willis Faber Dumas, where each sheet of glass is hung by means of patch plates from the sheet above, each pane in the FT wall is independently restrained.

The 12mm thick, 2m square panes establish the grid for both the long facades. The glazed section is 16m high and 96m long, in clear glass for the press hall and banded in solar tinted and black emulsified glass (again reminiscent of the Daily Express buildings) for the offices, where the obscured section conceals the intermediate floors[22]. A system of fixed sun louvres spanning between the columns, similar to that employed at the Rank Xerox Engineering Centre, 1988[23], was proposed for the south-facing office wall but became a victim of 'value engineering' at an early stage in the project.

The aerofoil profile columns from which the glazing is effectively hung are formed from two unequal, circular hollow section half-sections welded to flat steel connecting plates[24] A series of outrigging arms at 2m centres hold the 'dinner-plates', each of which has four adjustable bolt connections which mate with pre-drilled holes in the corners of four sheets of glass. Butt joints between the panes have a watertight black silicone seal.

Each outrigged column (set out at 6m centres) carries the weight of two full panes and half the weight of two further panes horizontally, and eight panes vertically. The glazing is suspended by tensioned rods, located behind each column and at the ends of the outriggers, which connect the 'dinner plates' and are tied to a triangulated plate assembly at the top and bottom of each column[25]. The outriggers appear at

first to be holding up the glass, but in fact primarily offer wind restraint.

Overall lateral stability is provided by paired I-section beams with tubular cross-braced connections which span above the heads of the columns[26], forming a perforated 'entablature' at a level slightly below parapet height at the building's solid clad ends.

Flexible cladding

The modular cladding system used for the main building and the external stair and lift towers comprises 2m high x 1m wide super-plastic aluminium panels held by a retention system developed jointly by the Grimshaw office and the cladding subcontractor. The panel module relates to that of the glazing but was governed by the maximum panel size that could be economically fabricated on existing production lines. Panels on the main block have a vacuum-formed rib-profile with a metallic grey Duranar PVF2 coating[27]; those on the towers are smooth and have a silver coil-coated PVF2 finish[28].

Grimshaw's development of flexible modular cladding systems began with projects completed by the Farrell-Grimshaw partnership in the mid-1970s. The Herman Miller Factory at Bath, 1976, has a proprietary curtain walling system incorporating insulated double-skin glass reinforced plastic panels,that are held in place with a standard zip-up neoprene gasket

22

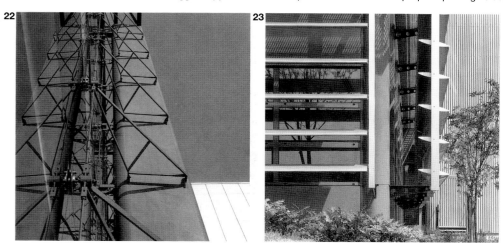

23

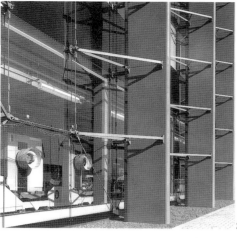

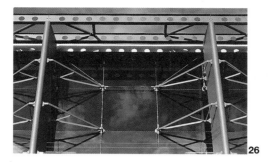

26

25

which allows doors, louvred, solid and glazed units to be interchanged or replaced in an infinite variety of positions[29]. The warehouse that Grimshaw completed for Herman Miller at Chippenham in 1982 combines proprietary and custom-made elements and introduced the perforated horizontal T-bar stiffening rail[30] that presages the FT's distinctive cladding rail. However, unlike those at the FT, the Herman Miller bars are not continuous, being interrupted by the gasketed vertical panel joints. In both cases the rails play a structural role, and also divert rain-water away from the face of the panel in order to reduce surface water run-off and staining.

But the FT departs from the precedent set in these projects by introducing a rain-screen cladding system on the main building. The key difference of course is that the FT's cladding wraps extremely simple industrial enclosures – the paper store and despatch bays – which do not require a complex range of openings or panel types.

The profiled panels have a continuous turned-down lip that locates both horizontally and vertically in channel-section aluminium cladding rails on the 2m x 1m panel grid[31]. A specially designed aluminium component forms a watertight cloak at the junction between the horizontal and vertical rails, thus allowing rain-water to drain through the system to ground level. A wide ventilated cavity between the inner face of the cladding and the insulated lining allows any potential condensation or penetrating water to evaporate harmlessly.

Economy and adaptability

The swept corners of the main block and the free-standing towers also continue stylistic and planning preoccupations that have held Grimshaw's interest since the 1960s. He has been working with streamlining and aerofoil profiles since the Park Road flats of 1967, where he took the corrugated stainless steel cladding round the corner to avoid a complex mitred junction[32]. And the argument that servicing should always be ancillary to structure is offered most concisely by the independent circulation and service tower for the International Student's Club of 1967.

There, to obviate the need for major structural alterations to a late l9th century terrace, a separate service tower was located in the rear courtyard. A central structural core doubled as a rising duct around which clusters of prefabricated bathroom pods were placed, served by a helical ramp that linked all floors of the old building earning Grimshaw the patronage of that greatest of 20th century innovators, Richard Buckminster-Fuller[33].

In more recent projects, in which parallels with the FT are more obvious, such as the Queens Drive Factory units at Nottingham, 1980, combined stair and service towers are placed at the perimeter of the plan to avoid compromising the flexibility of the factory space, which can then be laid out or subdivided at will. Additional towers can be placed at any point on the perimeter if required, as the use of the building changes.

These concerns for accommodating flexibility, change and movement within a free plan also formed an essential part of the FT brief: the building has to be able to adapt and change as the company grows and the printing process evolves.

In principle, the building could expand northward to accommodate a second line of presses.In practice the existing press capacity is already greater than the current support facilities can sustain, and these are the areas that will probably need to develop. Since the building opened in 1988 (the FT's centenary year) the St Clement's Press has won the contract to print the Observer. This takes place on Saturday nights when the presses would otherwise be inactive.

But as one area grows, another shrinks. The introduction of direct-line input by journalists will do away with the old labour-intensive cut-and-paste layout techniques which still prevail, and the old-fashioned composing room will eventually vanish. It seems likely that within a few years the building and the processes it houses will reach a new steady state. That is of course until satellite and TV technology and the fax machine conspire to make the printed page itself redundant.

27

28

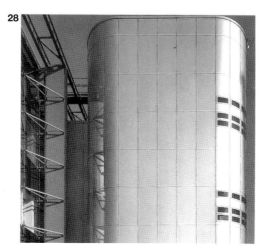

29

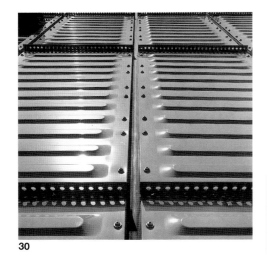

30

31

32

33

Photographs
Jo Reid
John Peck

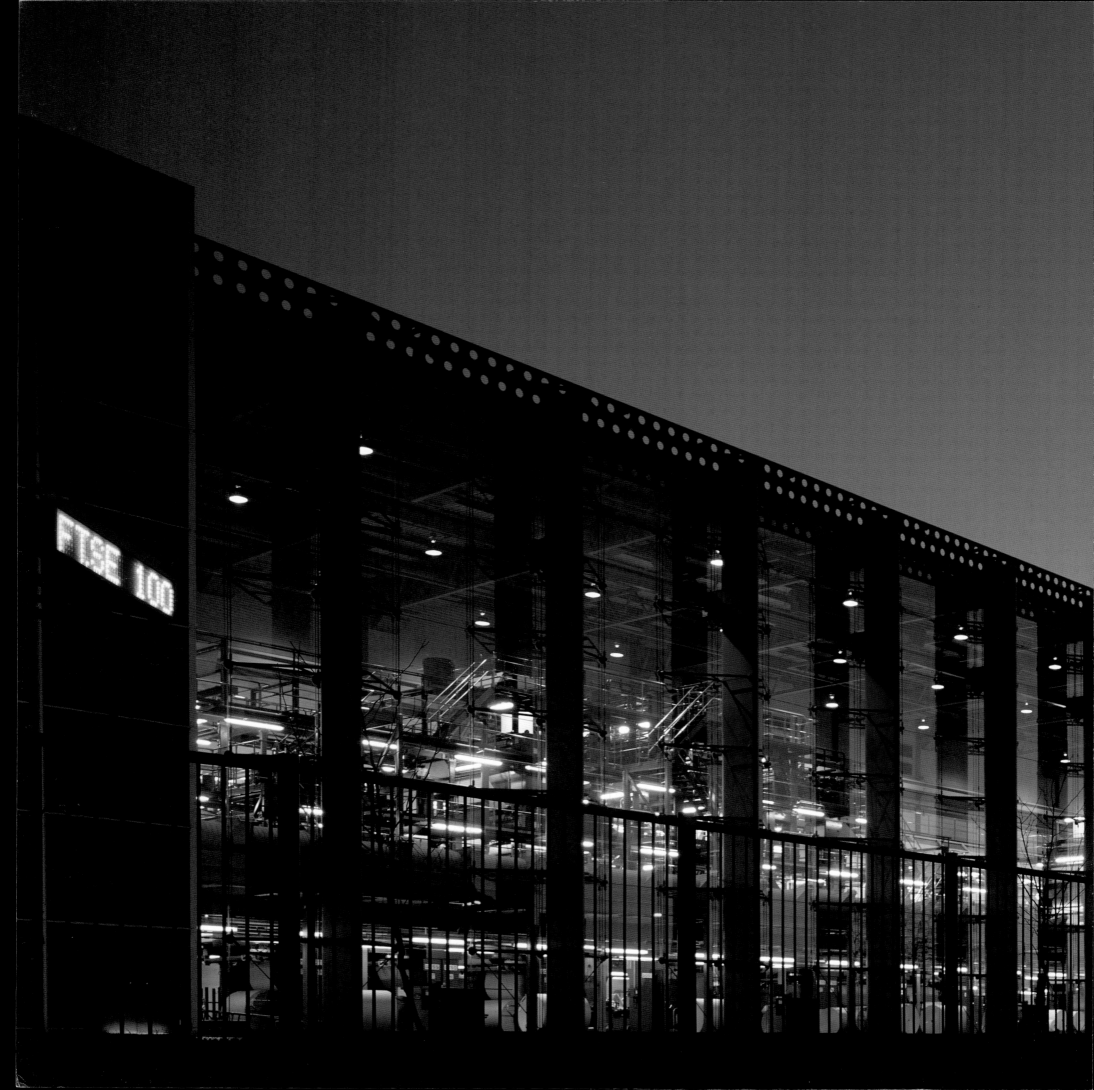

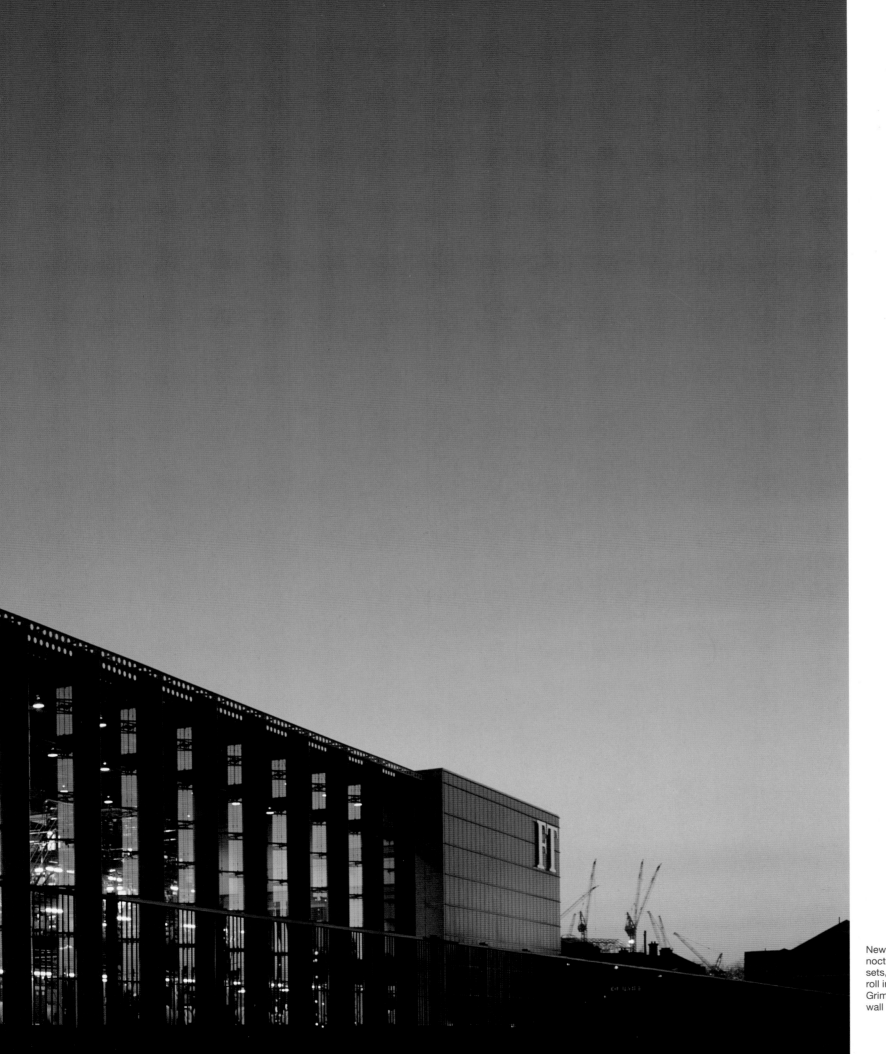

Newspaper printing remains a nocturnal activity: as the sun sets, the FT's high-tech presses roll into action behind Nicholas Grimshaw's spectacular glass wall

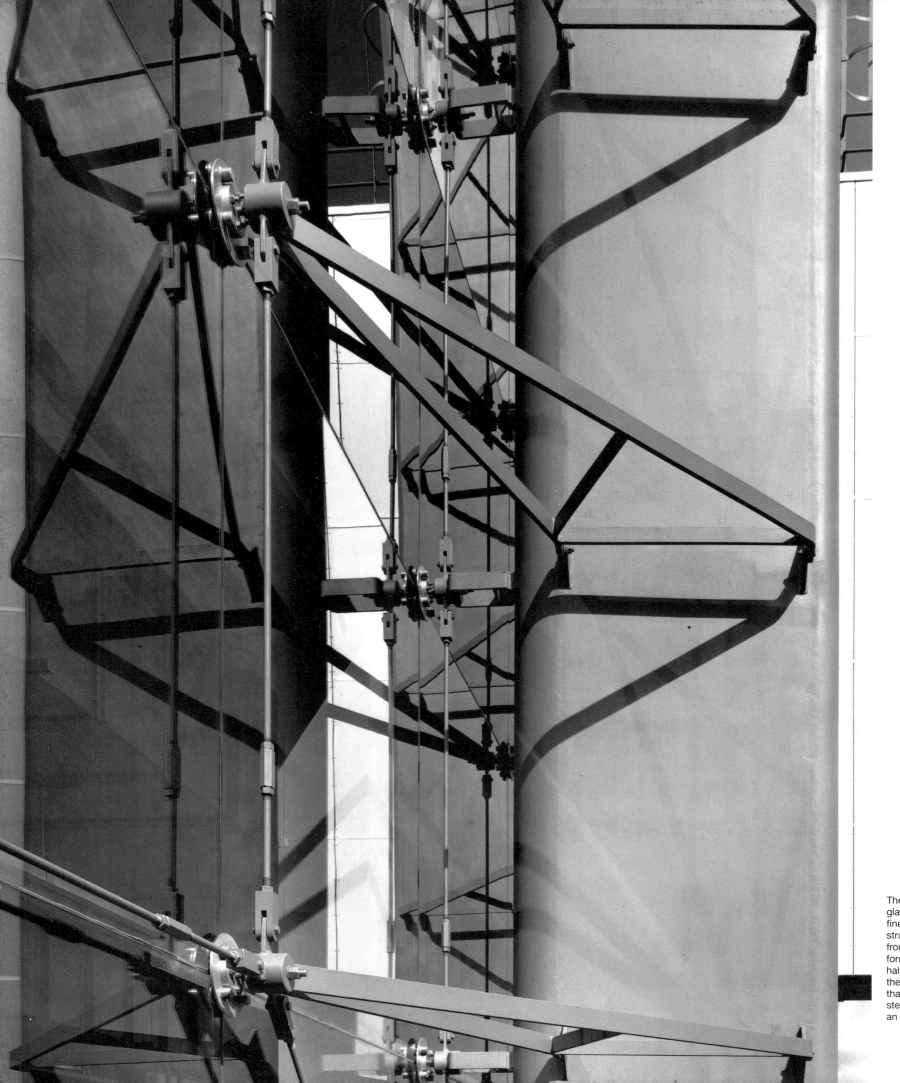

The building's two longitudinal glass walls are supported by a finely elaborated outboard structure. Each of the columns from which the glazing is hung is formed from two circular hollow half-sections, the one nearer to the glass being of larger radius than the other, welded to flat steel connecting plates to form an 'aerofoil' section.

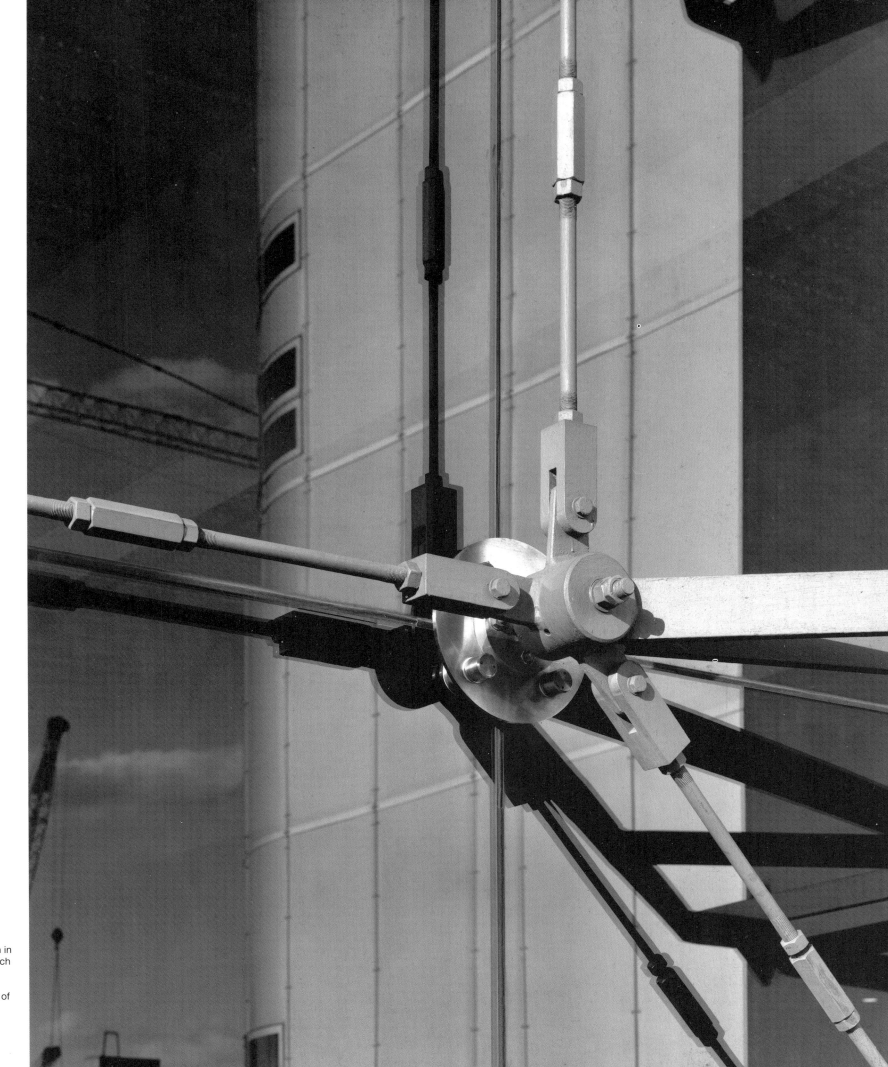

Outrigging arms at 2m centres
hold the circular connecting
plates (or 'dinner plates') which in
turn hold the glass in place. Each
plate has four adjustable bolt
connections which mate with
pre-drilled holes in the corners of
four sheets of glass.

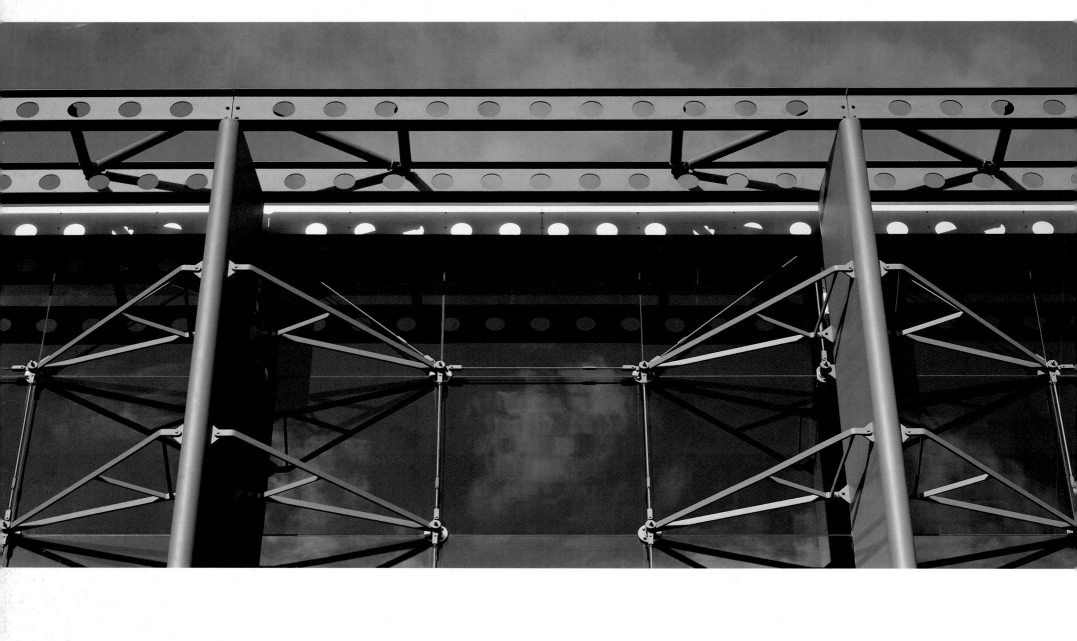

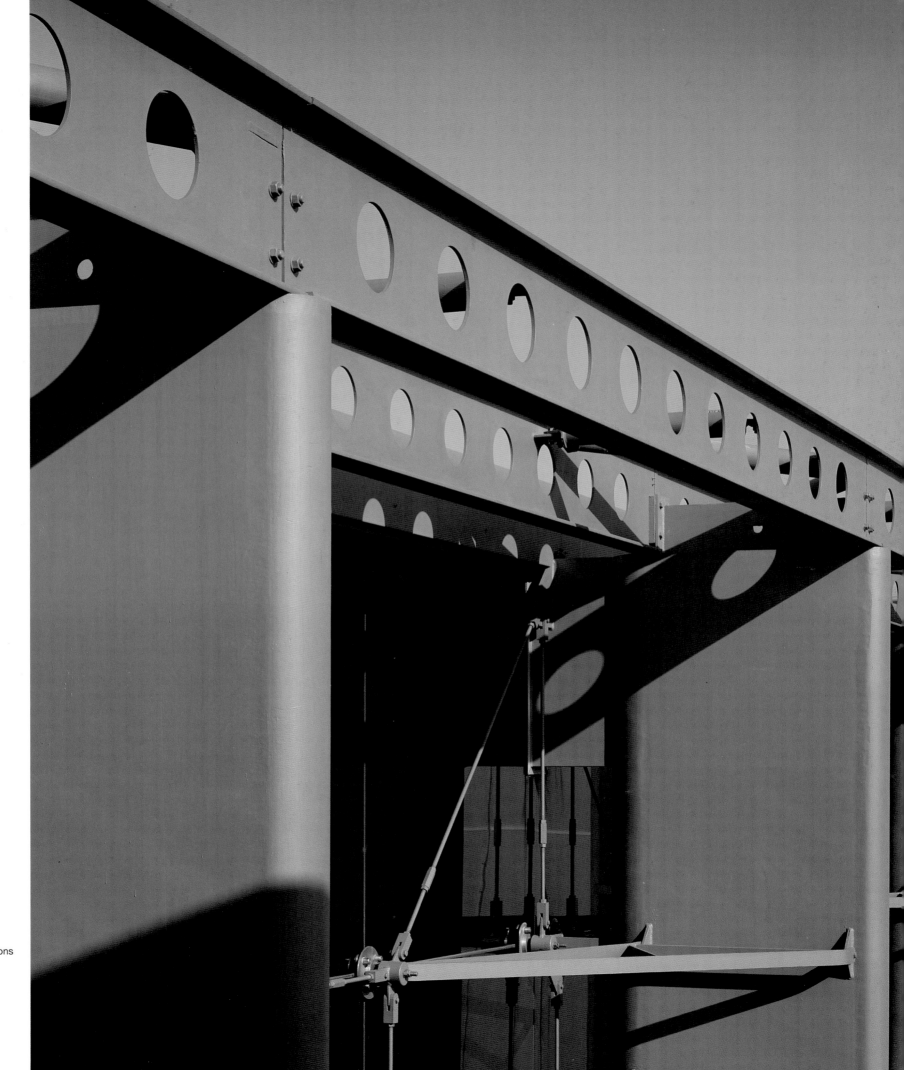

Paired I-section beams with tubular cross-braced connections span above the heads of the aerofoil columns, forming a perforated entablature and providing the structural frame with overall stability.

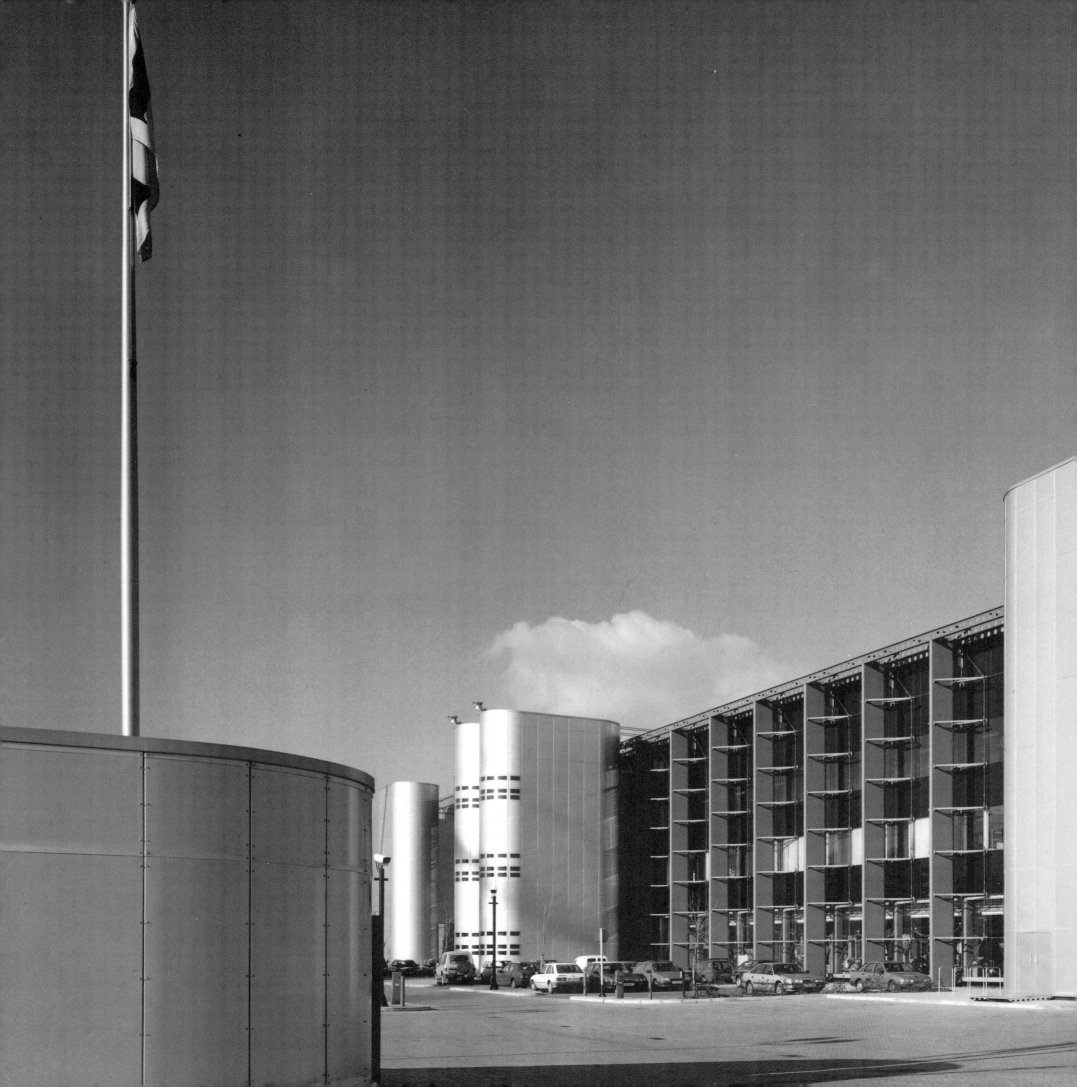

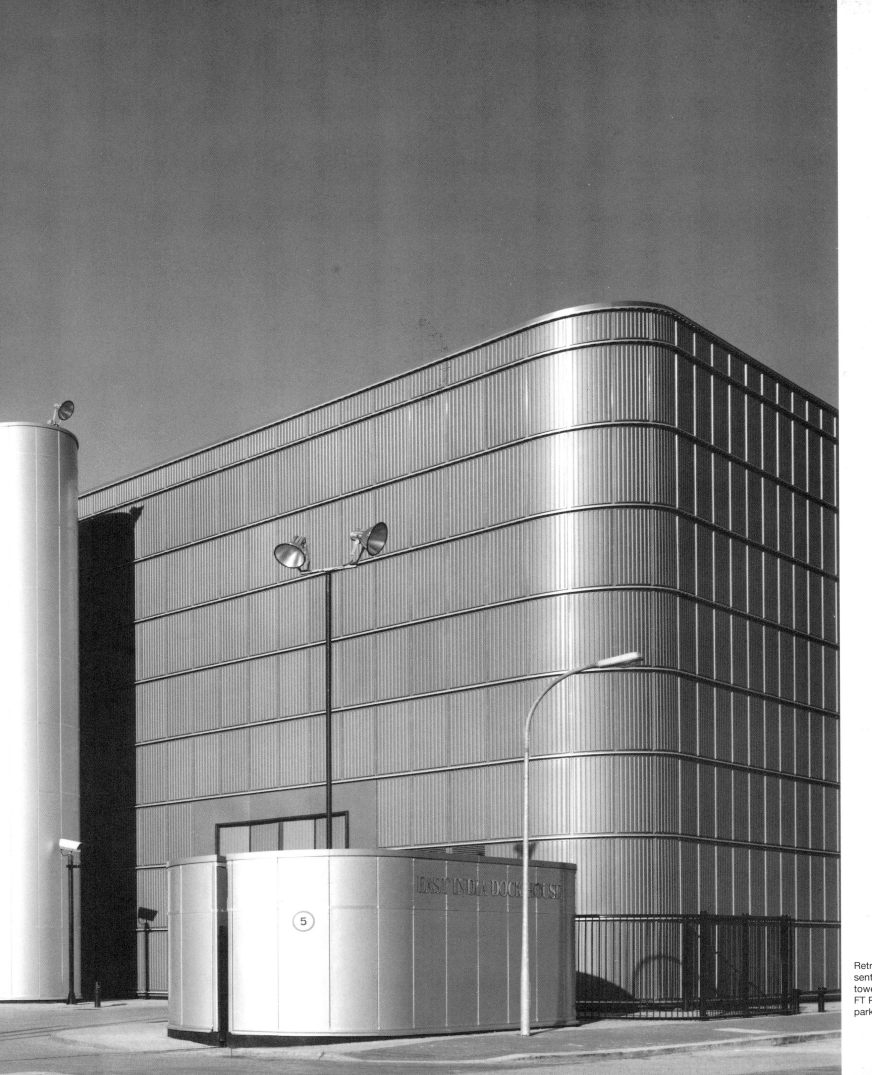

Retractable steel gates and the sentry-like stainless steel stair-towers mark the entrance to the FT Print Works and its car-parking compound.

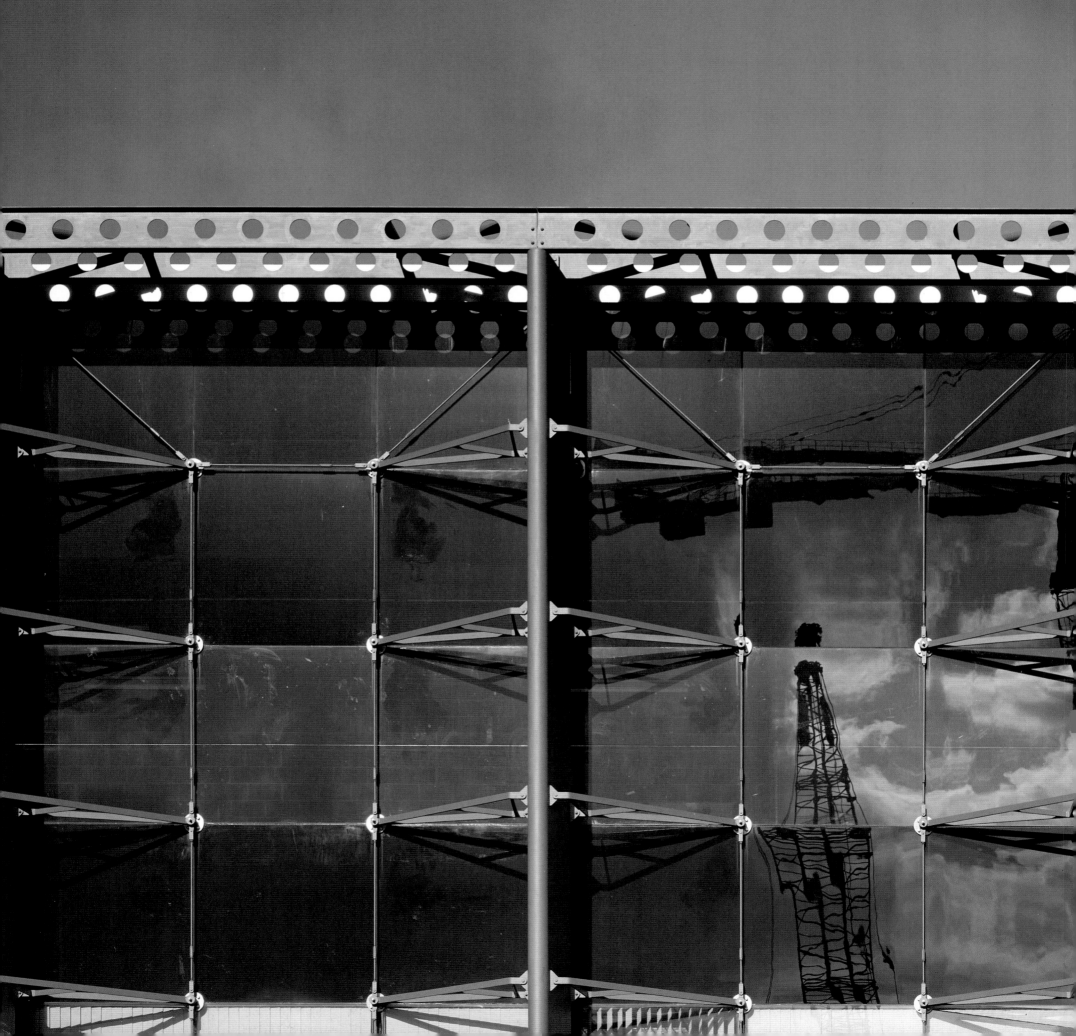

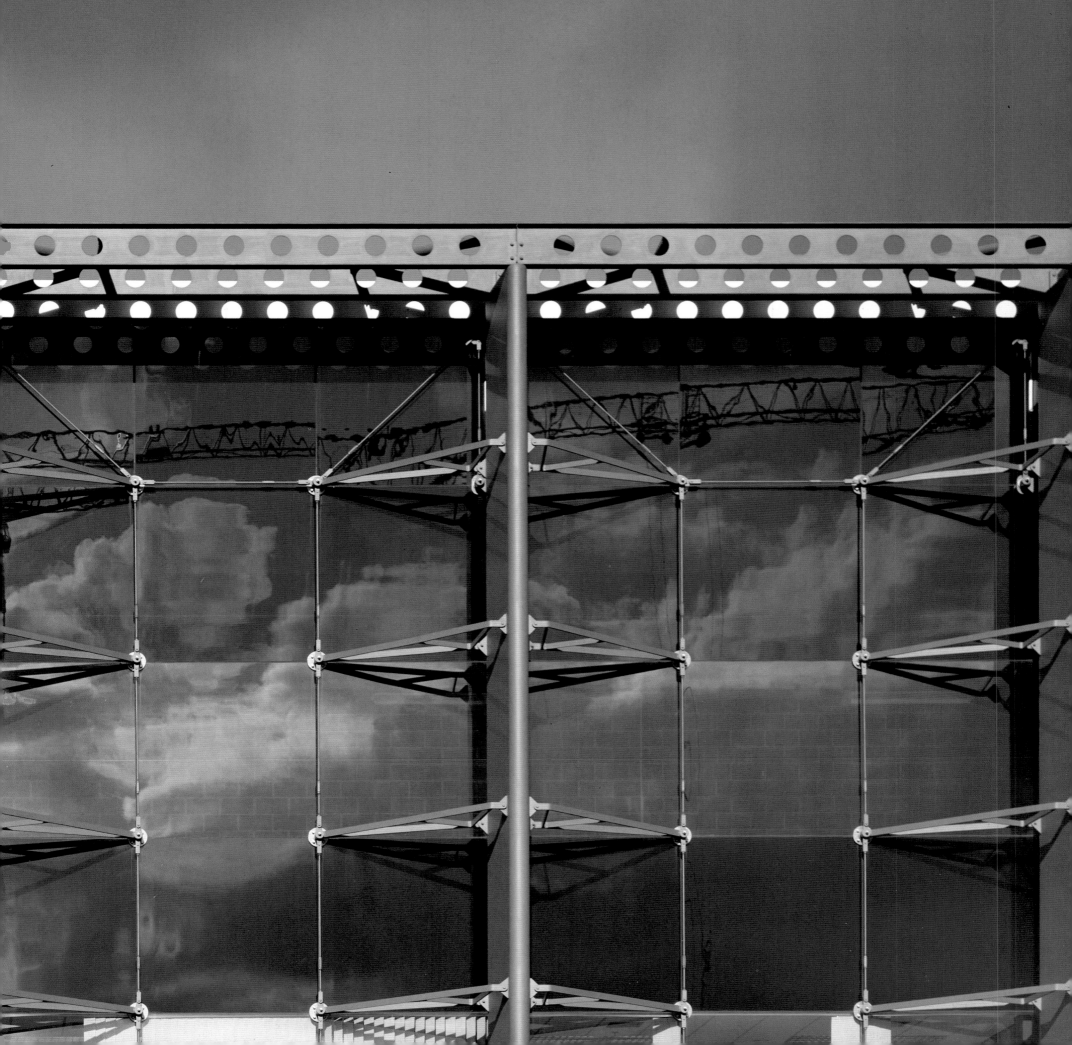

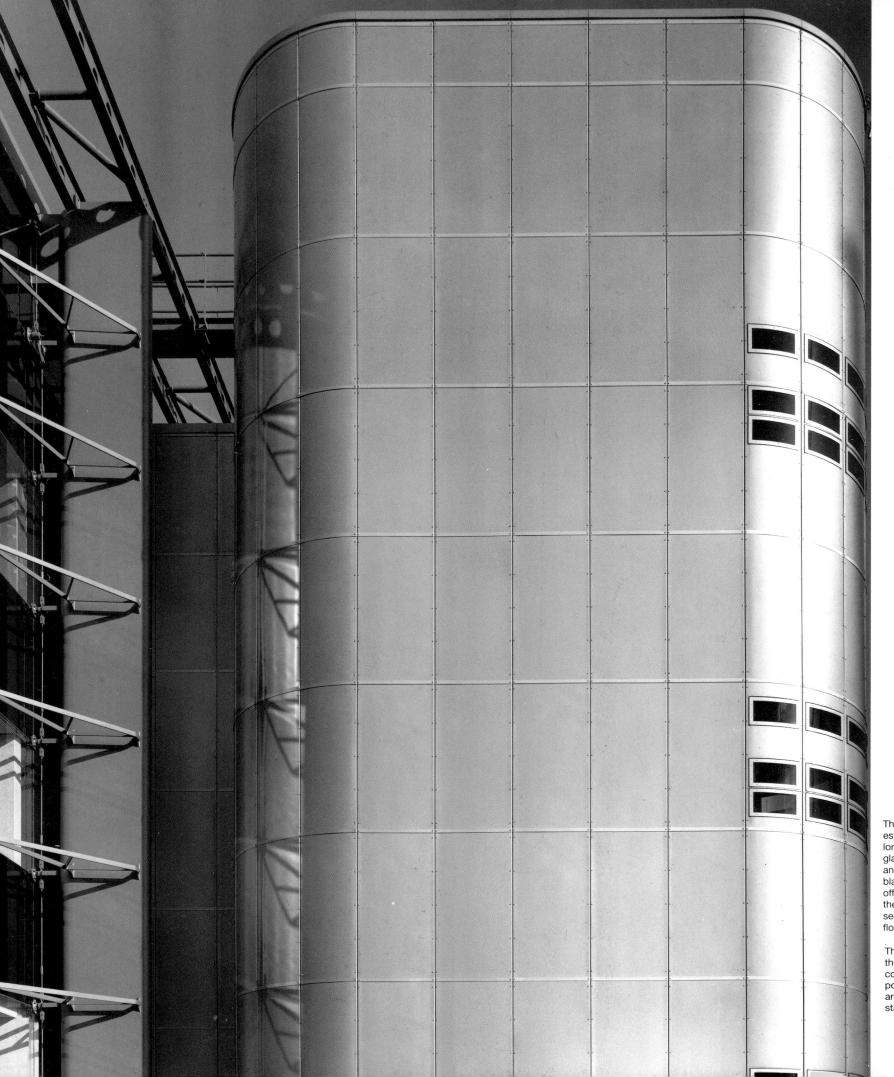

The 2m square glass panes establish the grid for the two longitudinal glazed facades, The glass is clear for the Press Hall, and banded in solar tinted and black emulsified glass for the offices on the southern side of the building, where the obscured section conceals the intermediate floors.

The smooth-finished panels on the staircase towers have a silver coil-coated PVF2 finish. Clear polycarbonate glazed windows are incised into the panels at the staircase landing levels.

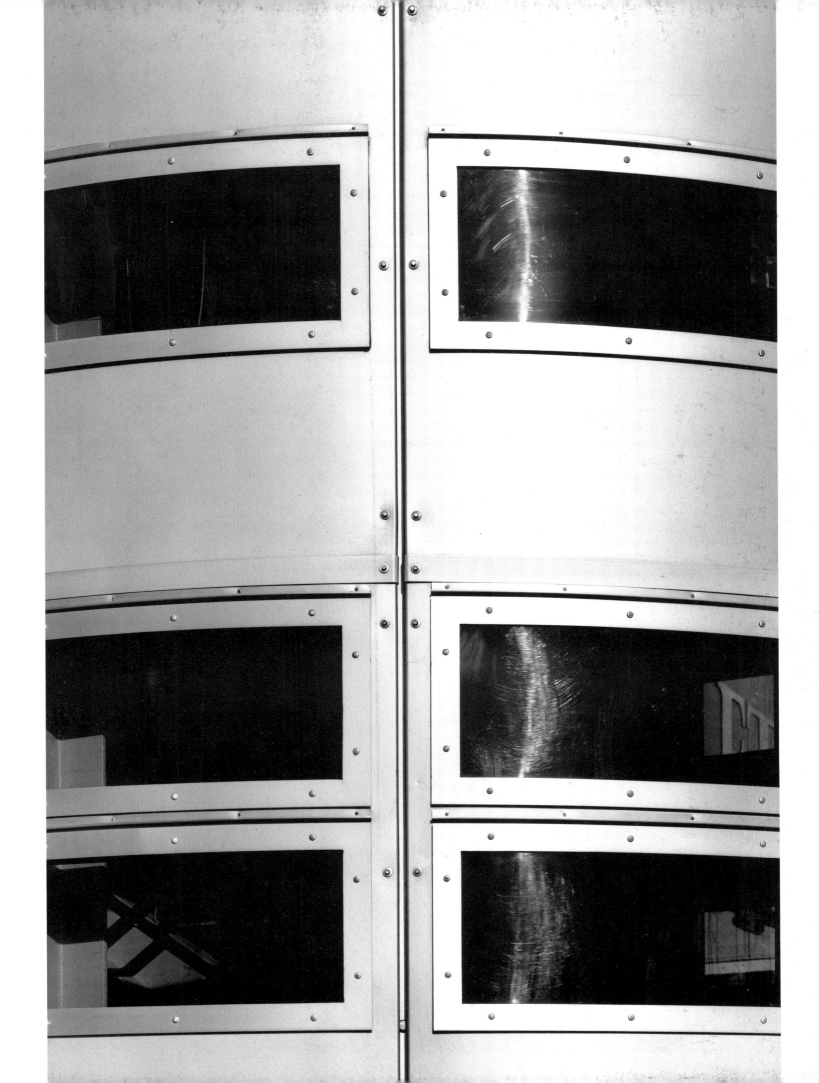

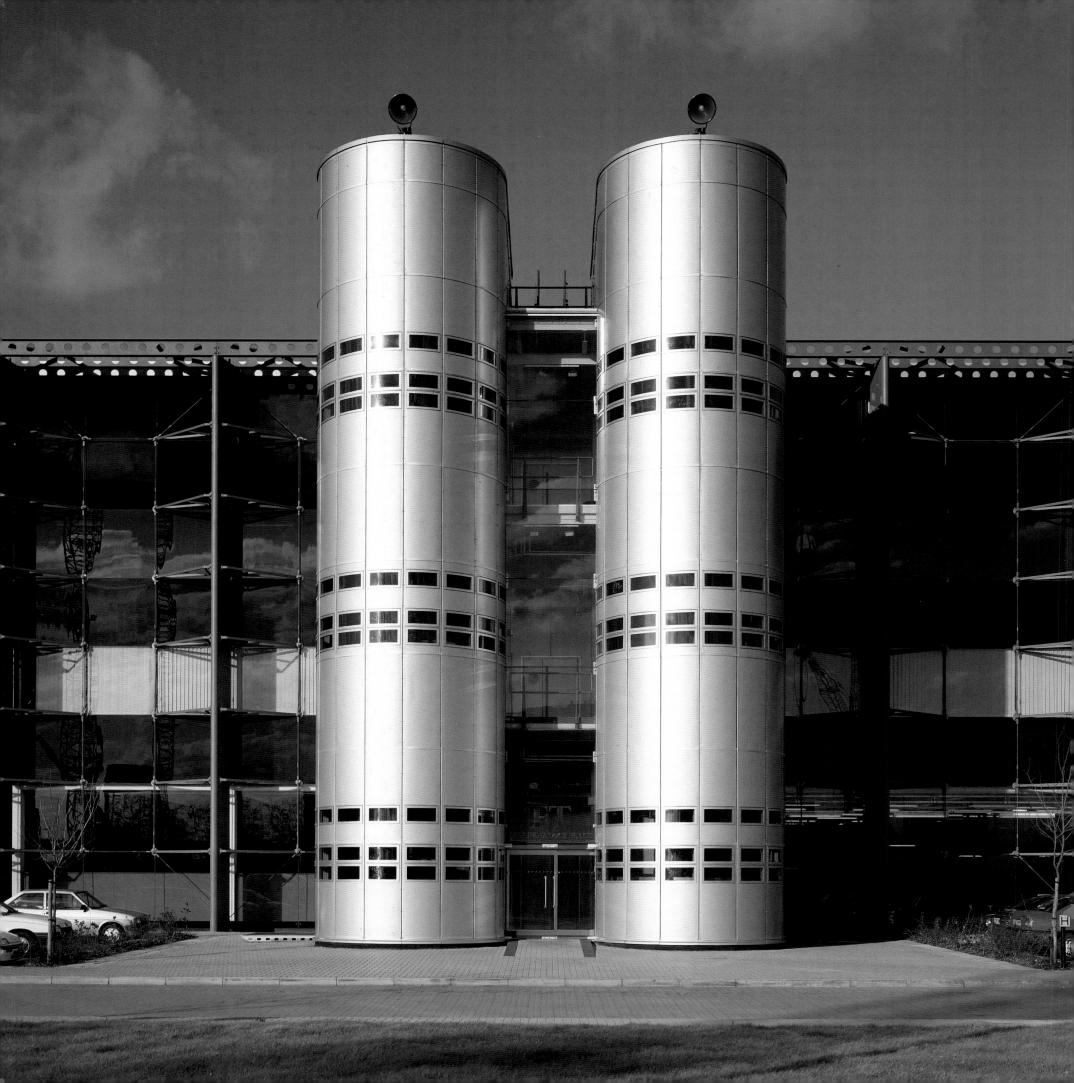

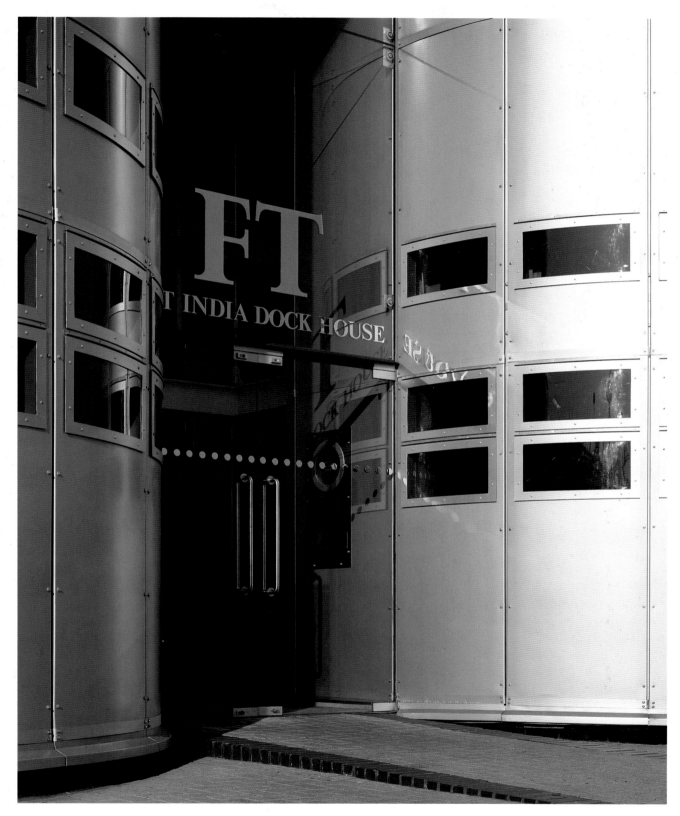

The free-standing staircase and elevator towers, which mark the entrance, are placed at the perimeter of the plan. They therefore avoid compromising the flexibility of the main accommodation floors, which can be laid out or subdivided at will.

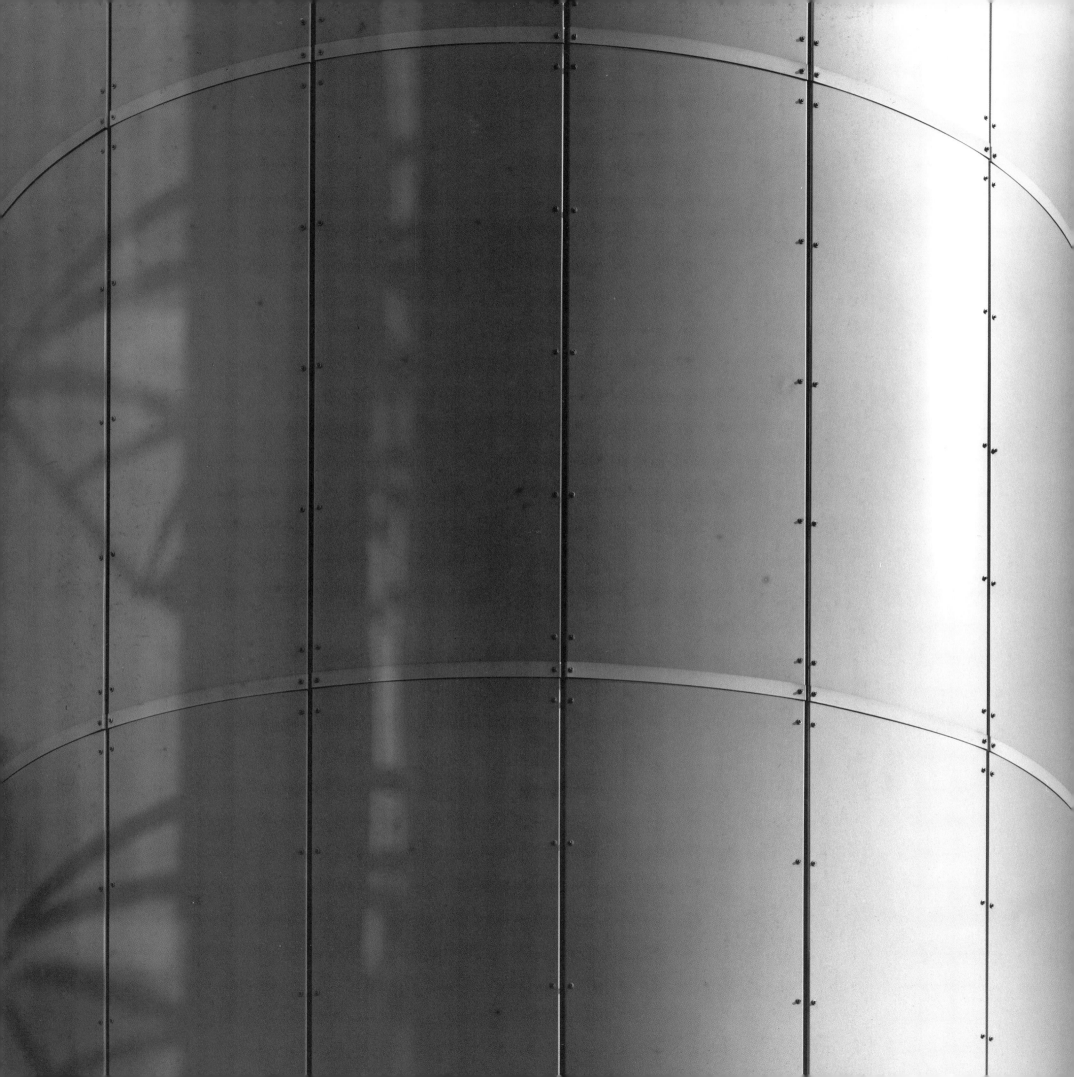

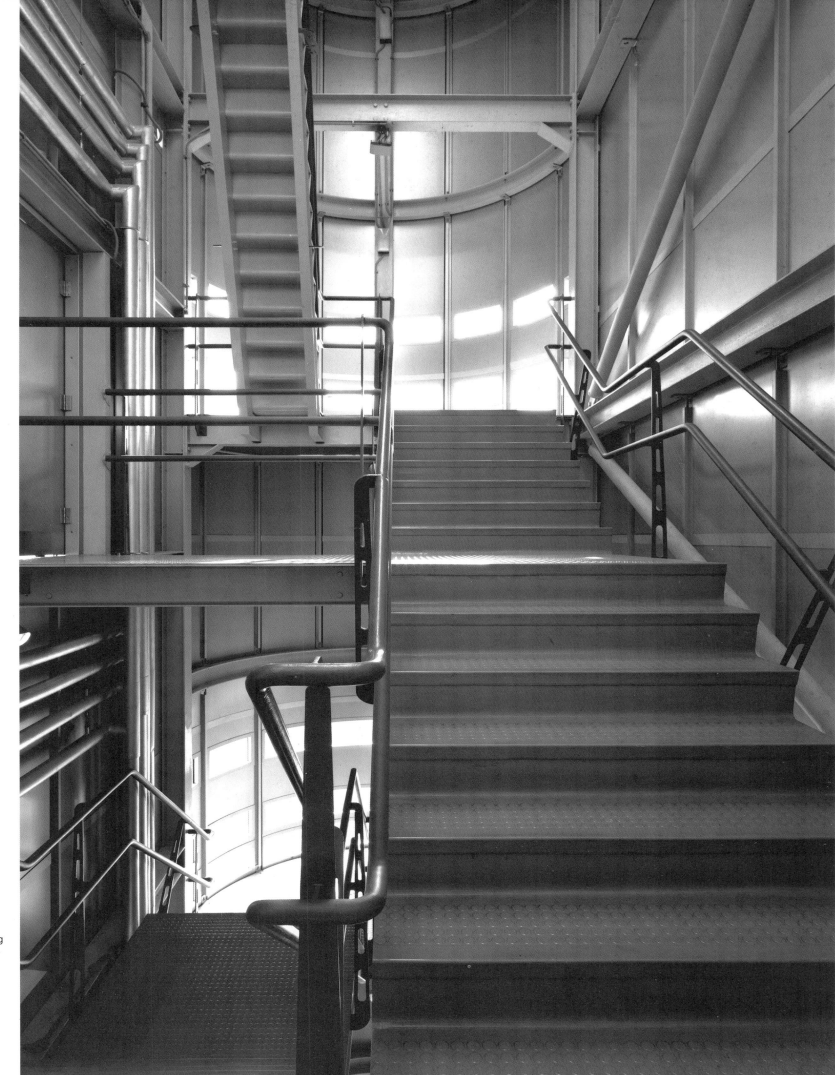

Beneath the taut skinlike cladding of the stair towers, the staircases are detailed with an industrial directness and economy of means. The electrical trunking and service ducts are left exposed.

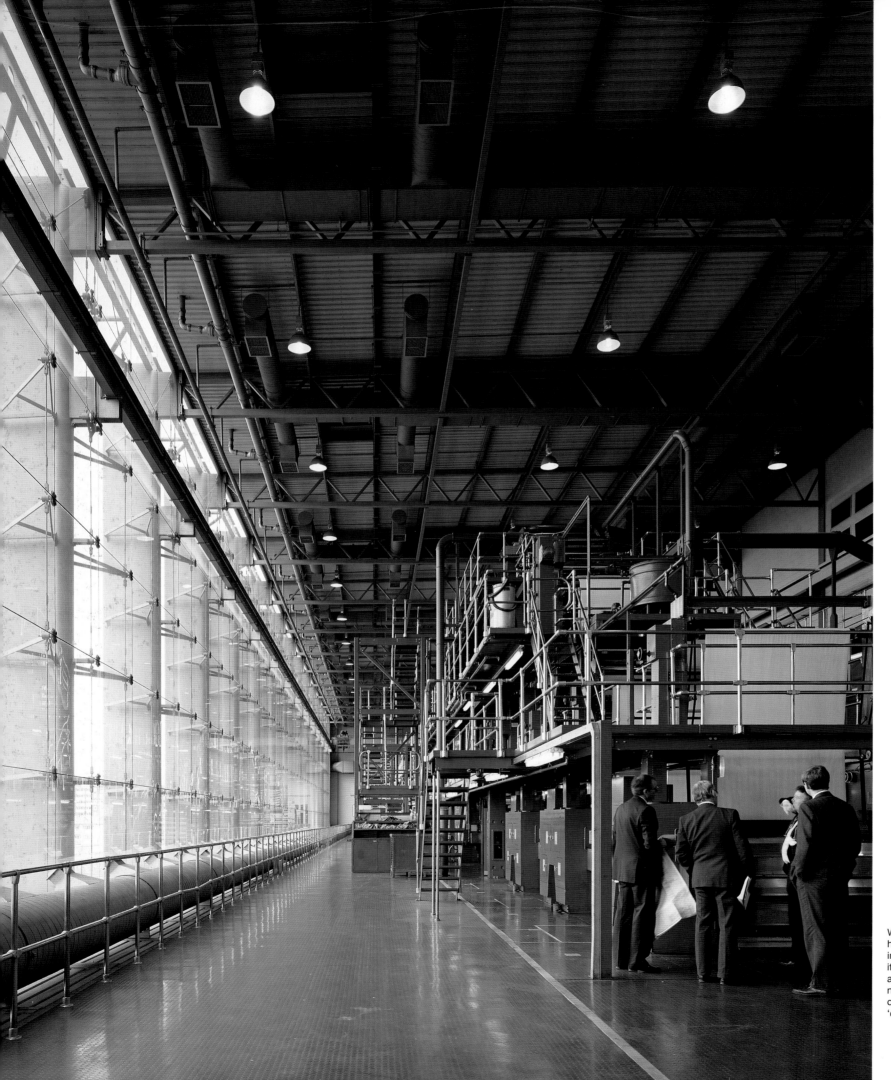

Within the vast Press Hall, the high-tech presses are effectively independent structures. Each has its own staircases, platforms and access galleries. Modern newspaper Press Halls must be counted among the new 'cathedrals of industry'.

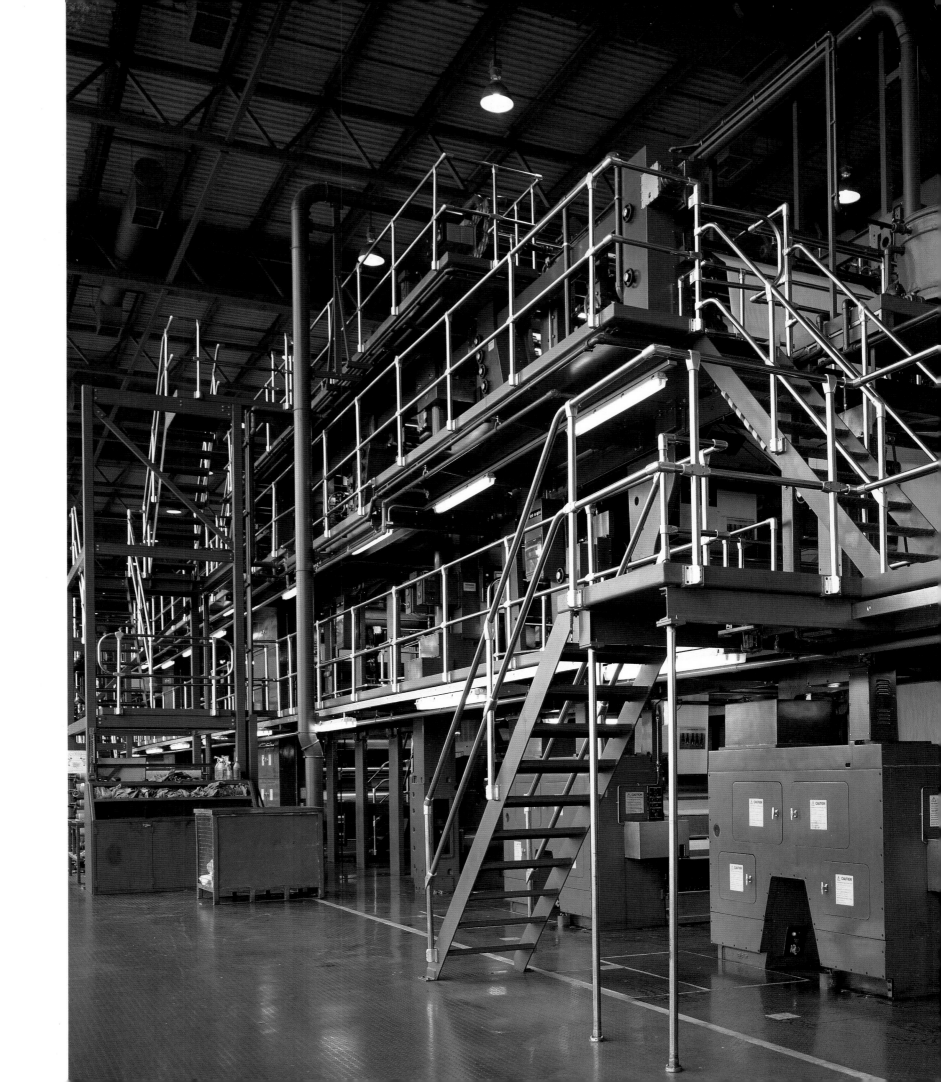

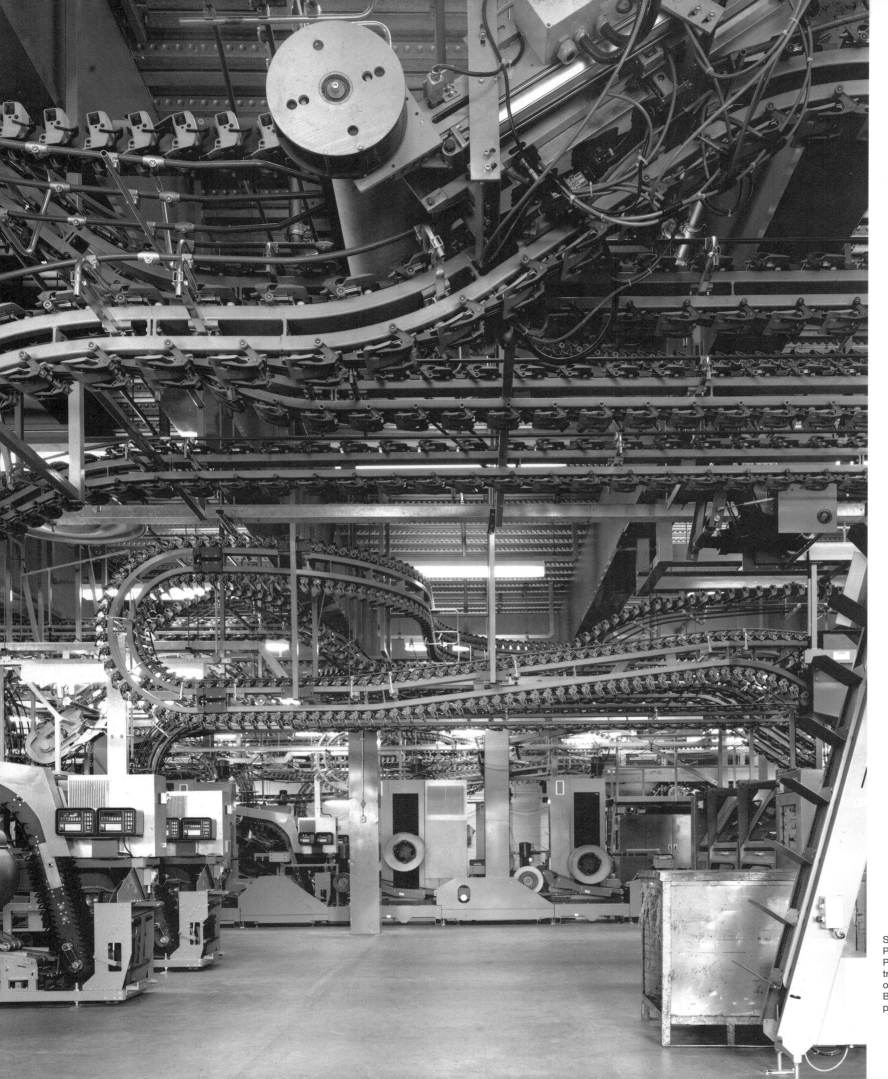

Specialist machinery in the Publishing Room (adjacent to the Press Hall) collects, collates and transports the newspapers on overhead tracks to the Despatch Bay where they are bundled up prior to distribution.

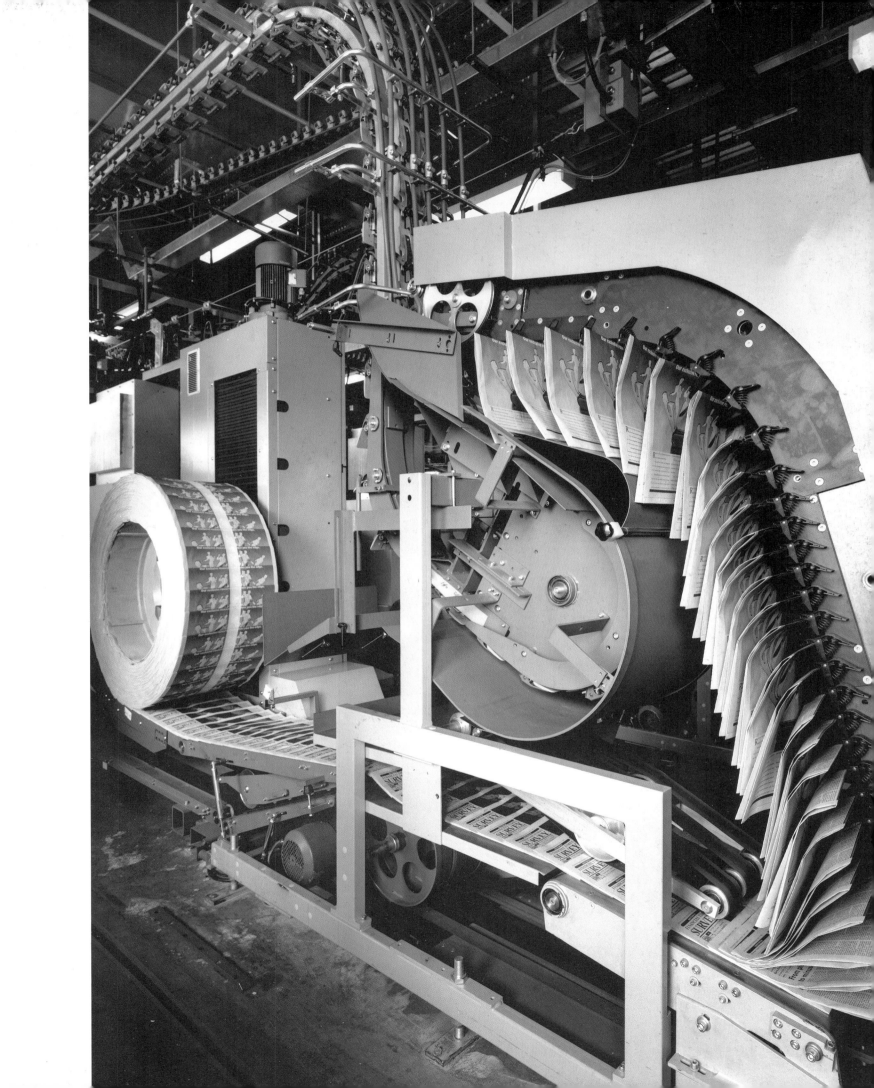

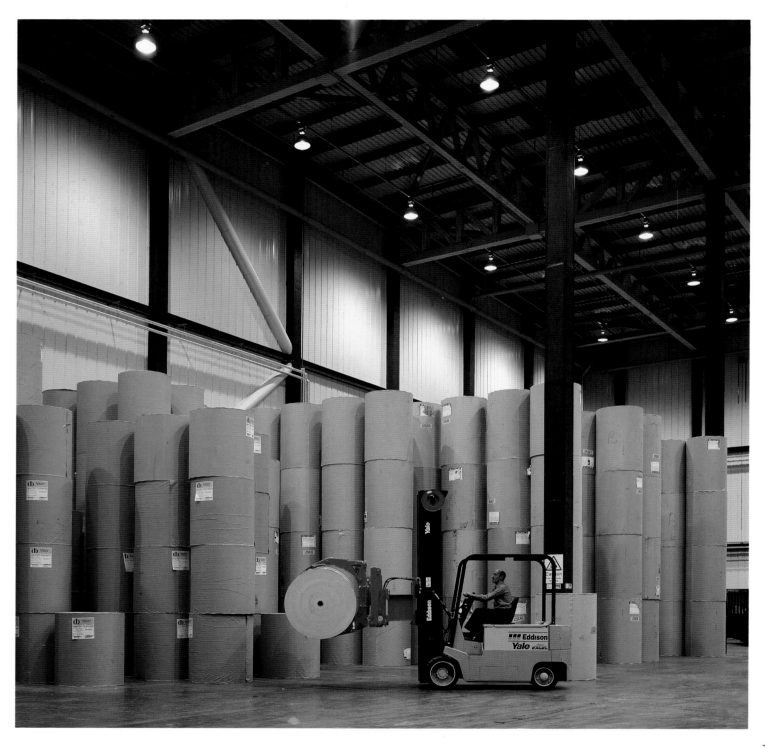

The Paper Store contains a three-week supply of newsprint for both the FT and the Observer (which is printed on the FT presses on Saturday nights).

From the Paper Store, the paper rolls (each of which weighs 1.75 tonnes – as much as the average family car) are manoeuvred through a system of in-floor conveyors and turntables and into the presses.

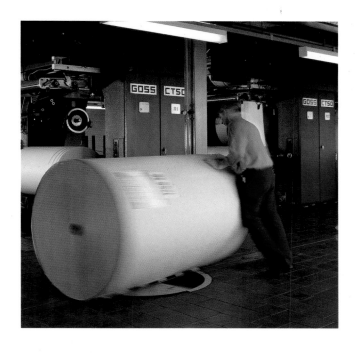
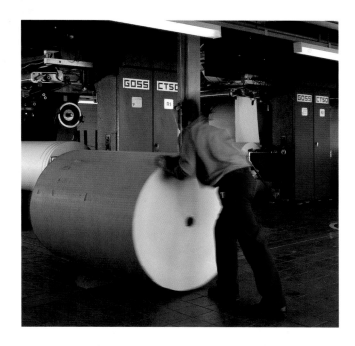
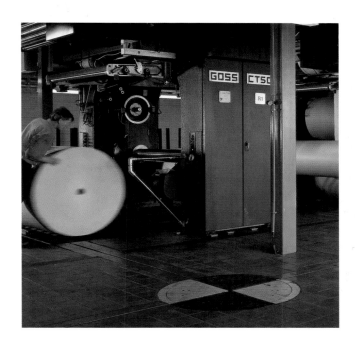
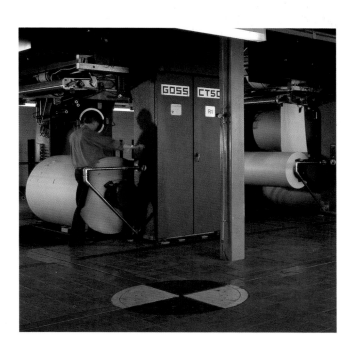

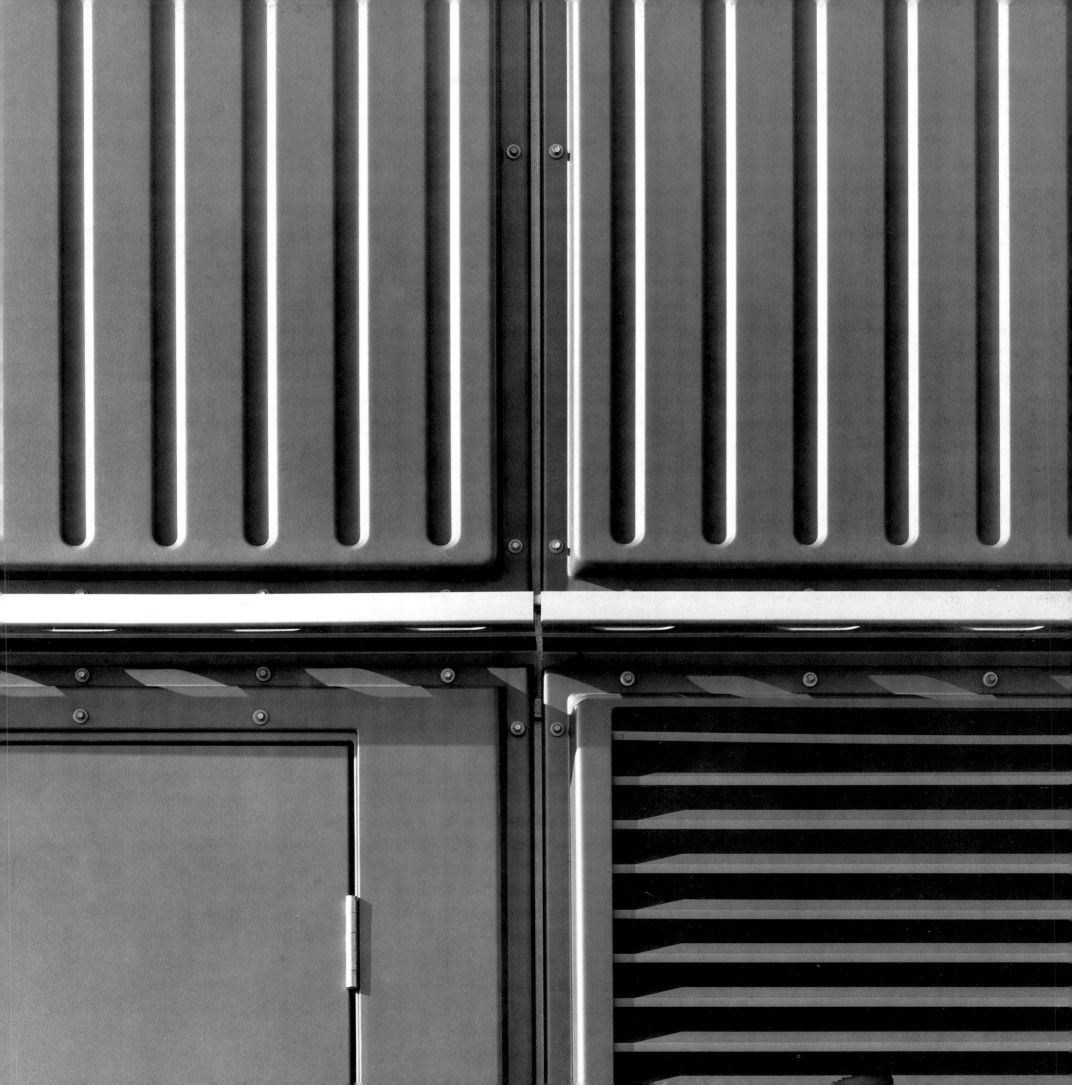

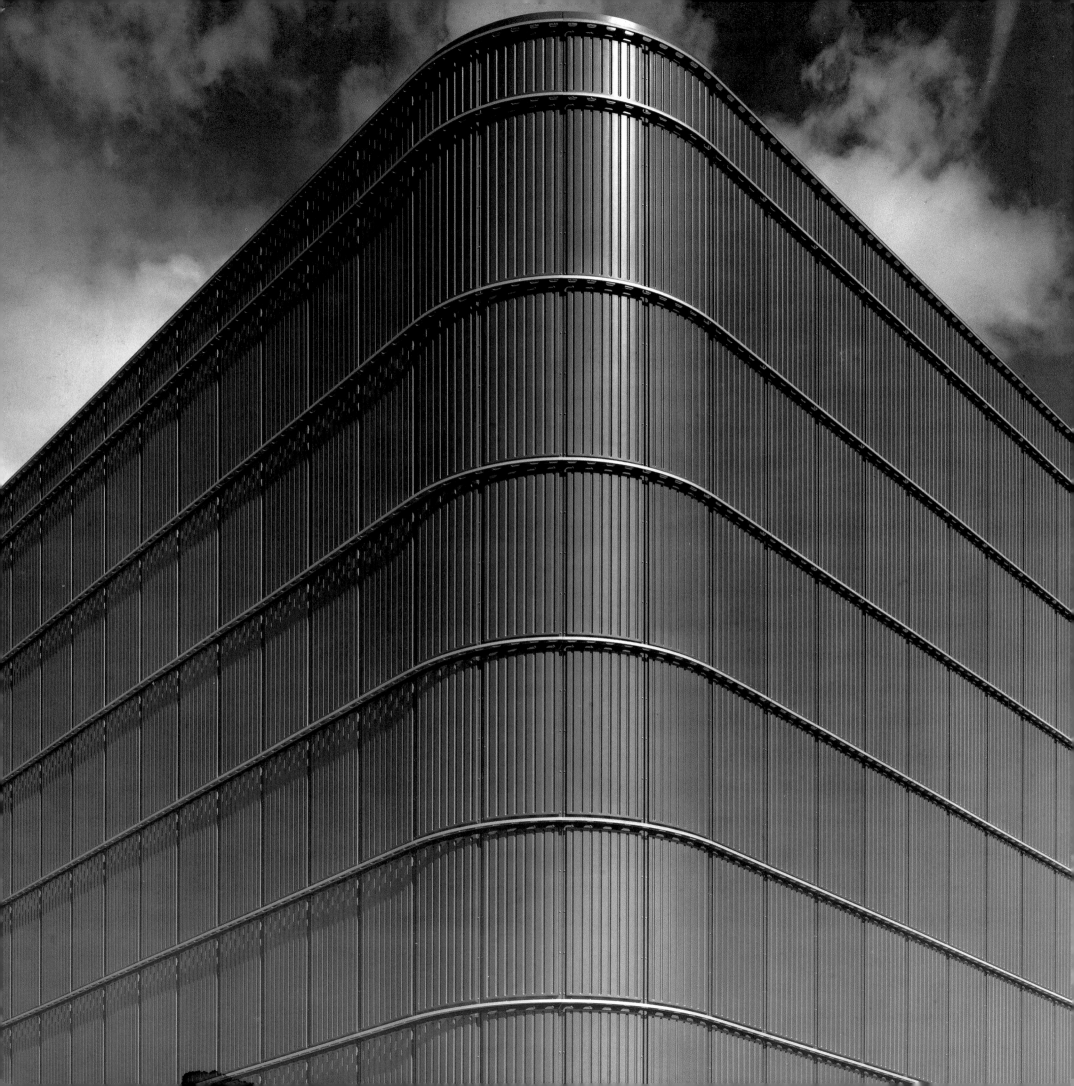

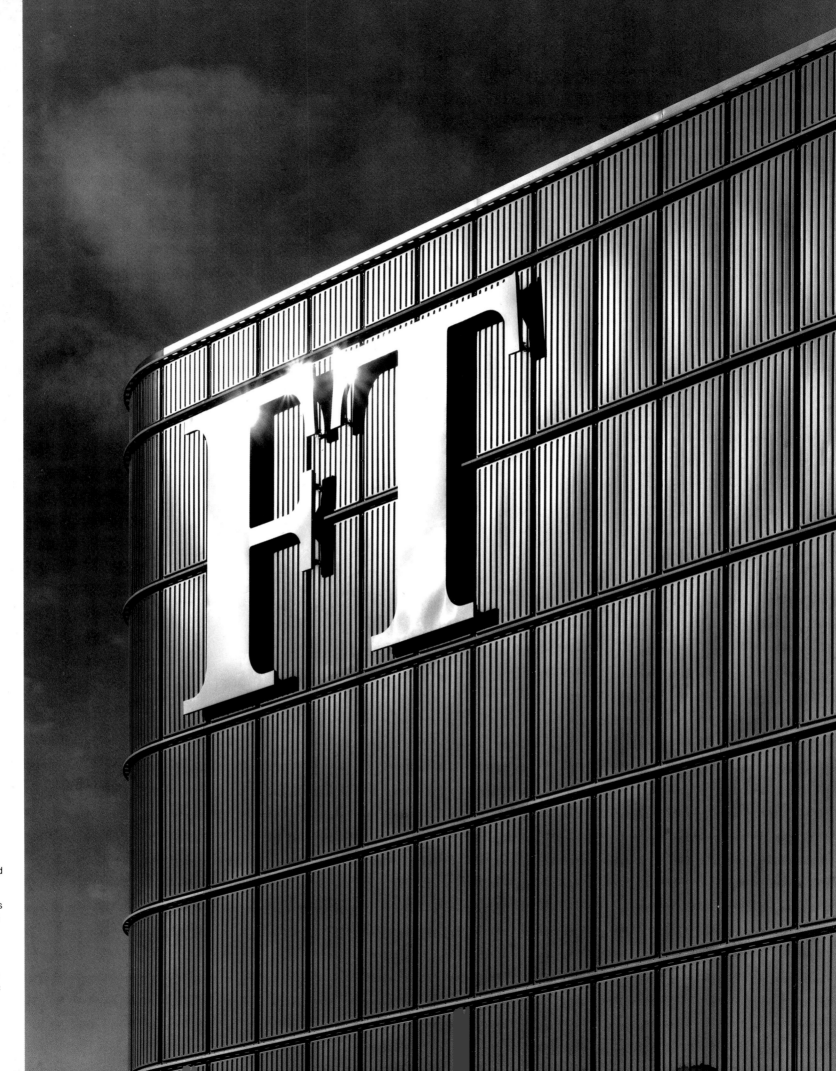

Panel junctions on the solid-clad ends of the building showing typical profiled panels, louvred ventilation panels and an access doorway; all of which fit into the overall 1 x 2m cladding grid.

The swept corners of the main block and the freestanding staircase tower are a Grimshaw trademark, continuing a stylistic theme that he has been developing since the sixties.

Drawings

Location plan
Scale 1:4000

1 Isle of Dogs
2 All Saints Station
3 All Saints Church
4 Rowlett Street housing
5 Robin Hood Gardens Estate
6 Reuters headquarters
7 Financial Times Print Works (East India Dock House)
8 East India Dock
9 Extension to Docklands Light Railway (DLR)

Site plan
Scale 1:2500

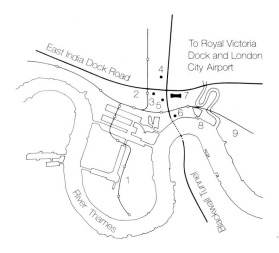

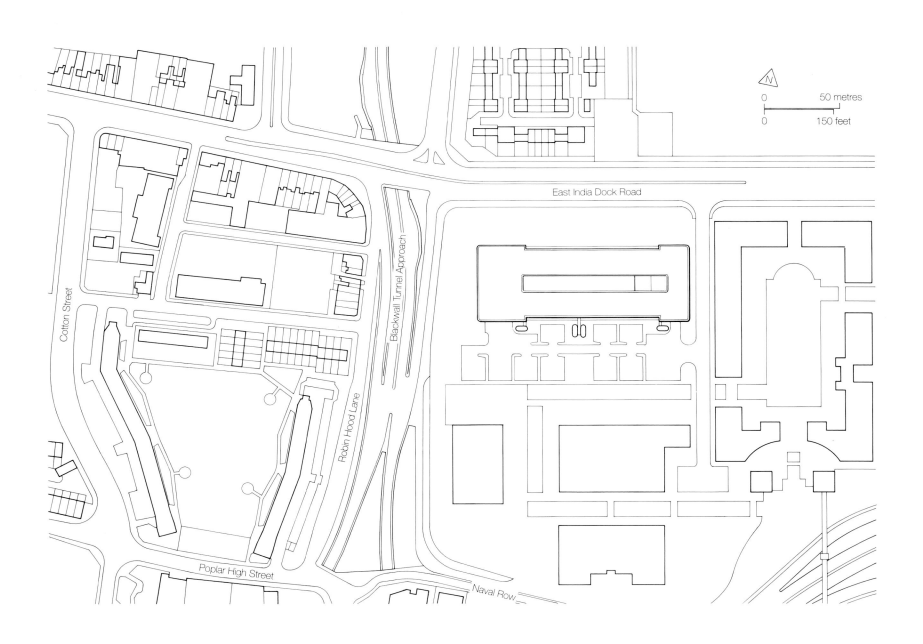

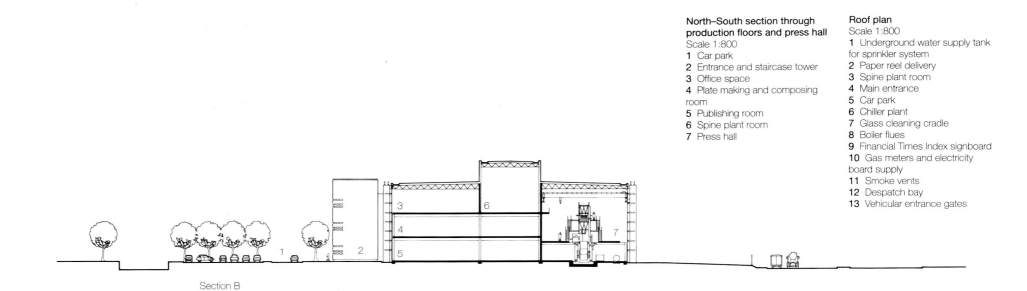

North–South section through production floors and press hall
Scale 1:800
1 Car park
2 Entrance and staircase tower
3 Office space
4 Plate making and composing room
5 Publishing room
6 Spine plant room
7 Press hall

Roof plan
Scale 1:800
1 Underground water supply tank for sprinkler system
2 Paper reel delivery
3 Spine plant room
4 Main entrance
5 Car park
6 Chiller plant
7 Glass cleaning cradle
8 Boiler flues
9 Financial Times Index signboard
10 Gas meters and electricity board supply
11 Smoke vents
12 Despatch bay
13 Vehicular entrance gates

Section B

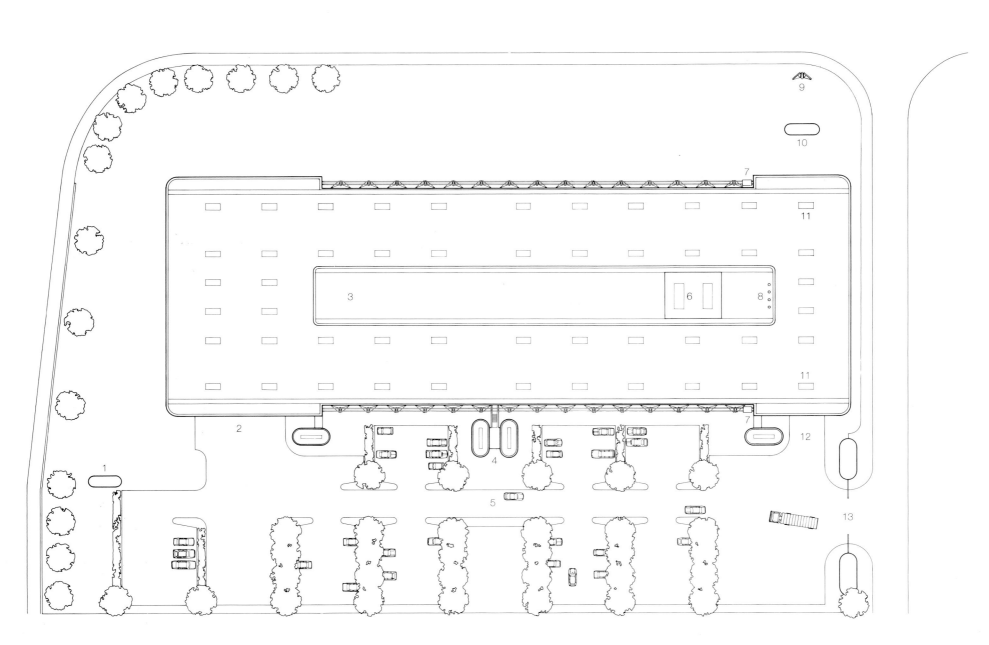

East–West section through the press hall
Scale 1:800
1 Paper storage
2 Press hall
3 Plant rooms
4 Ink store

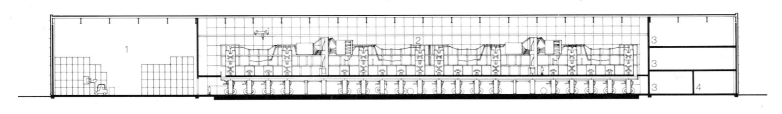

Section A

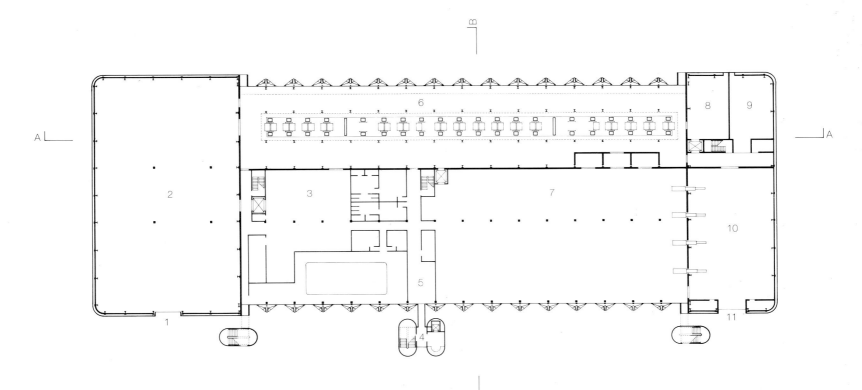

0 20 metres

0 50 feet

Ground floor plan
Scale 1:800
1 Paper reel delivery
2 Paper storage
3 Workshops
4 Entrance and security control
desk
5 Reception
6 Press hall
7 Publishing room
8 Plant room
9 Ink store
10 Despatch bay
11 Delivery trucks out

Nicholas Grimshaw's design sketches for the glazing support structure, dated 26 March 1987

The design tolerances for the whole assembly were gradually refined from Grimshaw's anticipated figures. There is a ±2.3° allowance for alignment of the boss face which is capable of adjustment by adding shims or washers to the glazing plates (dinner plates) during assembly.

The tie rods can be adjusted by ± 15mm to take account of local variations and overall tolerances of ±12mm in the glazing assembly. The actual design tolerances for the steel columns are ± 6mm in any plane.

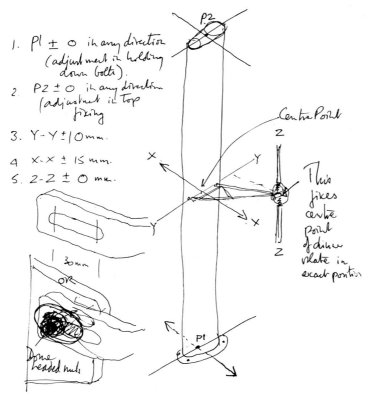

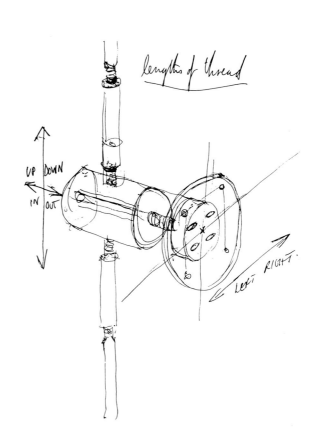

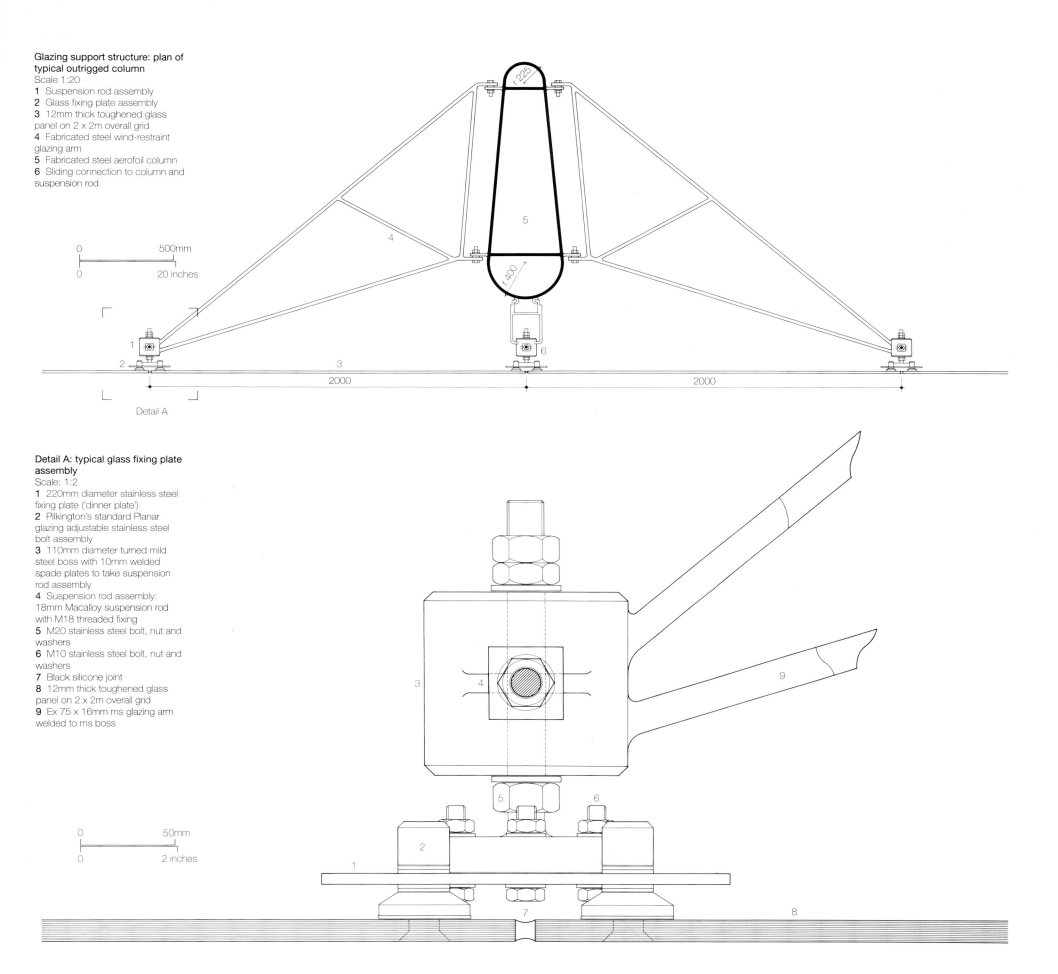

Glazing support structure: plan of typical outrigged column

Scale 1:20

1 Suspension rod assembly
2 Glass fixing plate assembly
3 12mm thick toughened glass panel on 2 x 2m overall grid
4 Fabricated steel wind-restraint glazing arm
5 Fabricated steel aerofoil column
6 Sliding connection to column and suspension rod

0 500mm

0 20 inches

Detail A

Detail A: typical glass fixing plate assembly

Scale: 1:2

1 220mm diameter stainless steel fixing plate ('dinner plate')
2 Pilkington's standard Planar glazing adjustable stainless steel bolt assembly
3 110mm diameter turned mild steel boss with 10mm welded spade plates to take suspension rod assembly
4 Suspension rod assembly: 18mm Macalloy suspension rod with M18 threaded fixing
5 M20 stainless steel bolt, nut and washers
6 M10 stainless steel bolt, nut and washers
7 Black silicone joint
8 12mm thick toughened glass panel on 2 x 2m overall grid
9 Ex 75 x 16mm ms glazing arm welded to ms boss

0 50mm

0 2 inches

Section through press hall glazed wall with part elevation
Scale 1:80

1 457 x 152mm UB beam with 230mm diameter holes at 500mm centres
2 18mm diameter Macalloy suspension rod with fork-end connectors
3 12mm thick toughened glass panel on 2 x 2m overall grid
4 Special bifurcated fixing plate assembly at crane rail bracket and beam end conditions
5 Typical fixing plate assembly
6 Overhead crane rail
7 Roof truss
8 Cast iron rain-water outfall pipe
9 Roof build up: single layer Trocal PVC membrane; 80mm Rockwool roofdecking slabs; high performance polythene vapour barrier; 35mm deep, 0.75mm thick profiled steel decking on purlins at 1500mm centres
10 Air duct
11 Fabricated steel aerofoil column
12 Fabricated steel wind restraint glazing arm
13 Fire path at 0.00m level
14 Typical suspension rod base plate assembly
15 French drain with gravel in drainage channel
16 Paper reel transported on in-floor conveyor system

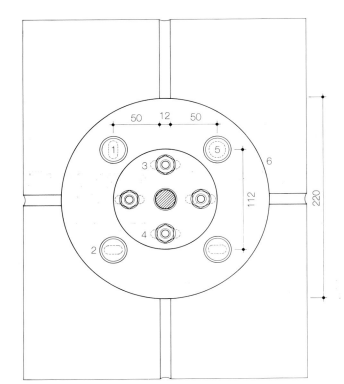

Detail B: glass fixing plate ('dinner plate')
Scale 1:4

1 9 x 18mm vertical slotted hole in plate
2 9 x 18mm horizontal slotted hole in plate
3 M10 stainless steel bolt, nut and washers
4 11 x 35mm horizontal slotted hole
5 18mm diameter hole in plate
6 220mm diameter stainless steel fixing plate ('dinner plate')

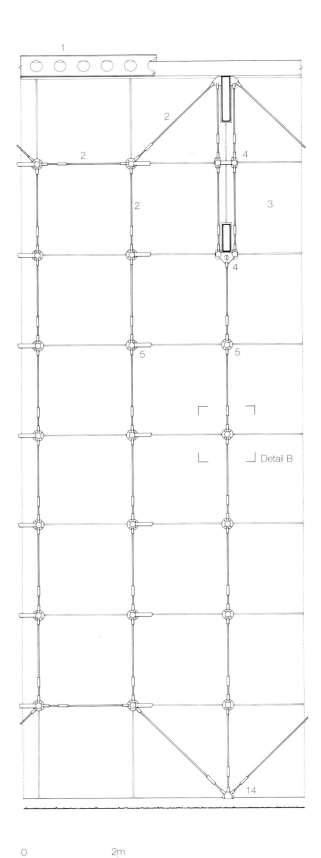

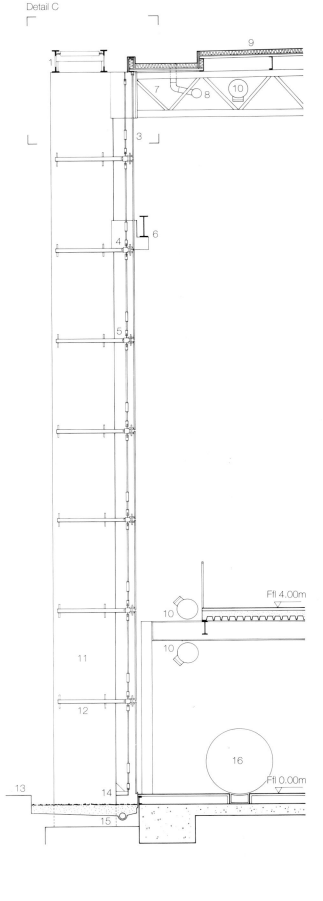

Detail C (from previous page)
at press hall eaves level
Scale 1:8

1 457 x 152mm UB beam; 230mm diameter holes in beam at 500mm centres
2 100mm ms plate welded closing pieces and spade connectors to brackets on beams
3 230mm bracketed upstand on top of column
4 Fabricated steel aerofoil column
5 Box-section beam end bracket, 1m deep
6 Suspension rod assembly: 18mm diameter Macalloy rod with M18 threaded fixing to 40 x 40 x 160mm machined fork-end connectors
7 10mm thick ms-plate welded to beam end
8 12mm thick clear toughened glass panel on 2 x 2m overall grid
9 Extruded aluminum glass restraining channel secret fixed to RSC above, with neoprene isolating strip and weatherproof seals
10 305 x 102mm RSC parapet edge channel
11 PVF2 coated steel parapet flashing with galvanized pressed ms fixing strap
12 Trocal metal closing pieces
13 Trapezoidal Corofil filler blocks
14 Roof build up: single layer Trocal PVC membrane; 80mm Rockwool roof decking slabs; high performance polythene vapour barrier; 35mm deep, 0.75mm thick profiled steel decking on purlins at 1500mm centres
15 Roof truss

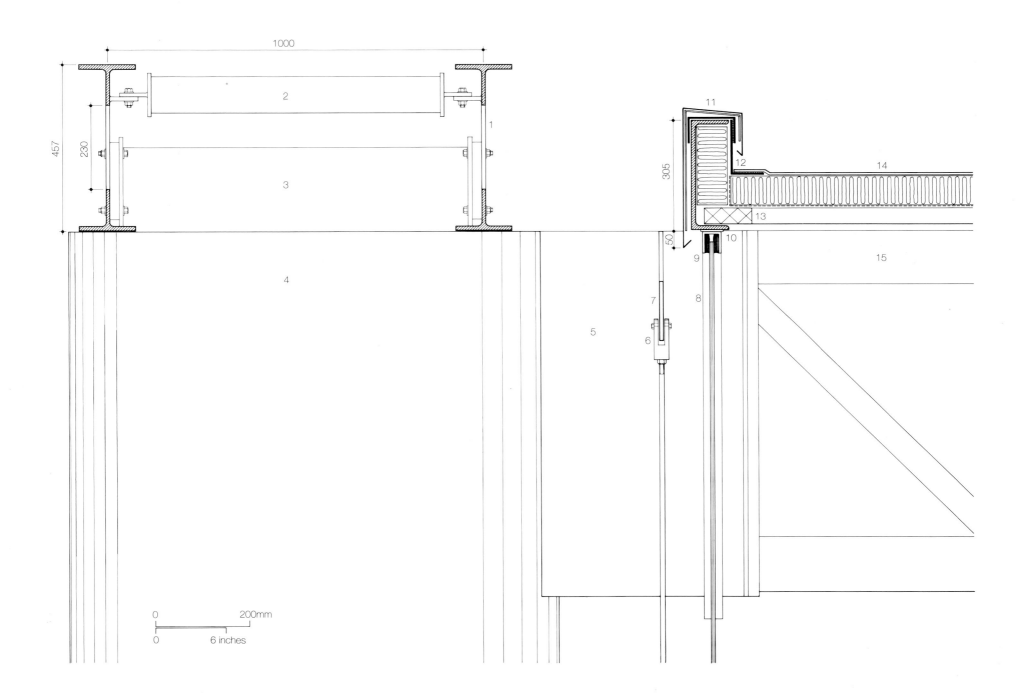

1000

457

230

305

50

0 200mm

0 6 inches

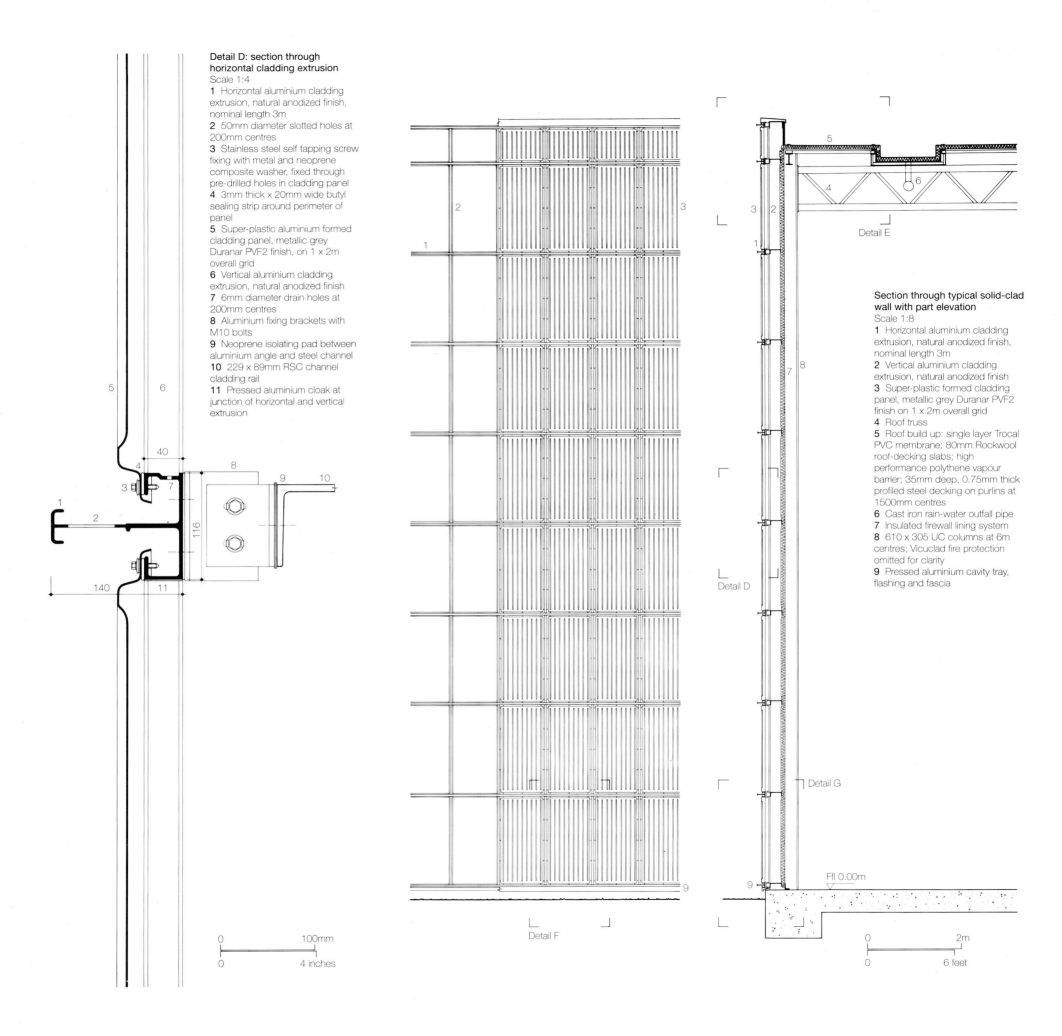

Detail D: section through horizontal cladding extrusion
Scale 1:4
1 Horizontal aluminium cladding extrusion, natural anodized finish, nominal length 3m
2 50mm diameter slotted holes at 200mm centres
3 Stainless steel self tapping screw fixing with metal and neoprene composite washer, fixed through pre-drilled holes in cladding panel
4 3mm thick x 20mm wide butyl sealing strip around perimeter of panel
5 Super-plastic aluminium formed cladding panel, metallic grey Duranar PVF2 finish, on 1 x 2m overall grid
6 Vertical aluminium cladding extrusion, natural anodized finish
7 6mm diameter drain holes at 200mm centres
8 Aluminium fixing brackets with M10 bolts
9 Neoprene isolating pad between aluminium angle and steel channel
10 229 x 89mm RSC channel cladding rail
11 Pressed aluminium cloak at junction of horizontal and vertical extrusion

Section through typical solid-clad wall with part elevation
Scale 1:8
1 Horizontal aluminium cladding extrusion, natural anodized finish, nominal length 3m
2 Vertical aluminium cladding extrusion, natural anodized finish
3 Super-plastic formed cladding panel, metallic grey Duranar PVF2 finish on 1 x 2m overall grid
4 Roof truss
5 Roof build up: single layer Trocal PVC membrane; 80mm Rockwool roof-decking slabs; high performance polythene vapour barrier; 35mm deep, 0.75mm thick profiled steel decking on purlins at 1500mm centres
6 Cast iron rain-water outfall pipe
7 Insulated firewall lining system
8 610 x 305 UC columns at 6m centres; Vicuclad fire protection omitted for clarity
9 Pressed aluminium cavity tray, flashing and fascia

Detail E

Detail D

Detail G

Detail F

Ffl 0.00m

40

8

9 10

4

3 7

116

1

2

140

11

0 100mm

0 4 inches

0 2m

0 6 feet

Detail E at solid-clad wall eaves level

Scale 1:10

1 Horizontal aluminium cladding extrusion assembly, natural anodized finish

2 Super-plastic aluminium formed cladding panel, metallic grey Duranar PVF2 finish on 1000 x 800mm overall grid

3 Vertical aluminium cladding extrusion, natural anodized finish

4 Steel parapet flashing, metallic grey Duranar PVF2 finish

5 Pressed galvanized ms fixing strap

6 300 x 500 x 100mm Trocal metal Zed section with self-tapping screw fixings to channel

7 300 x 150mm RSC capping channel

8 Trocal PVC membrane fully adhered to Trocal metal Zed section

9 Trocal PVC membrane mechanically fastened

10 Roof build up: single layer Trocal membrane; 80mm Rockwool roof decking slabs; high performance polythene vapour barriers; 35mm deep, 0.75mm thick profiled steel decking on purlins at 1500mm centres

11 Trapezoidal Corofil filler blocks

12 Insulated fire wall lining system, mechanically fixed

13 350 x 165mm UB beam spanning 6m

14 610 x 305mm UC columns at 6m centres; Vicuclad fire protection omitted for clarity

15 305 x 102mm RSC channel upstand spanning 6m

16 Roof truss

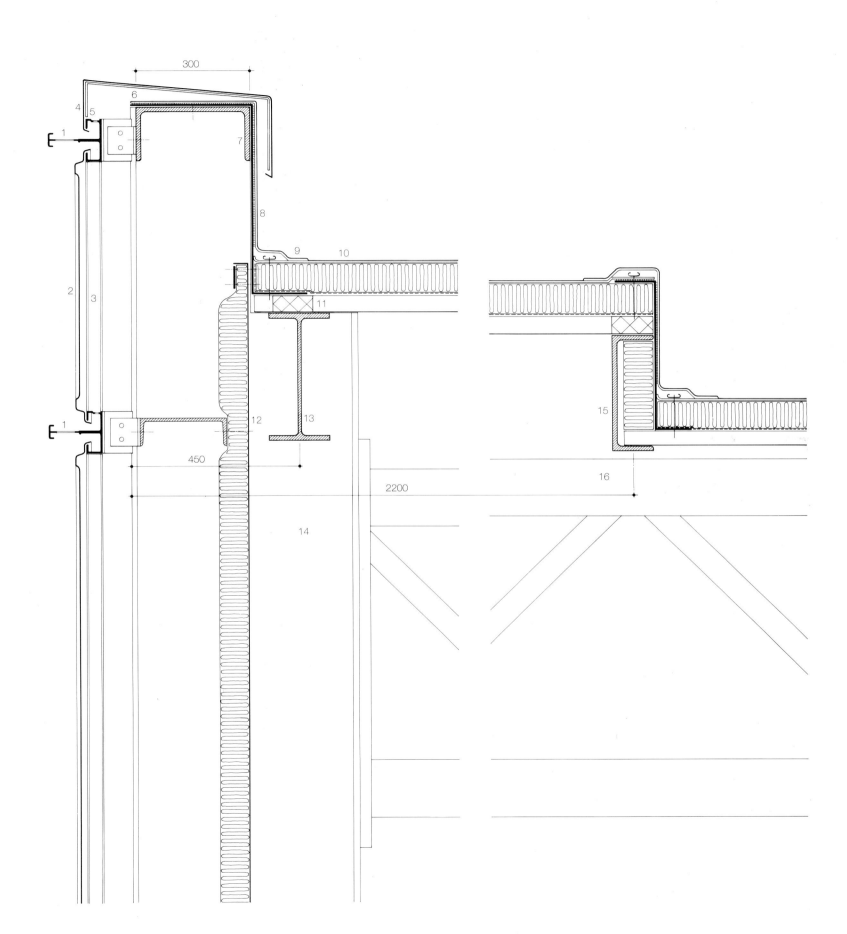

0 200mm

0 6 inches

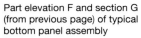

Part elevation F and section G (from previous page) of typical bottom panel assembly
Scale 1:10
1 Horizontal aluminium cladding extrusion assembly natural anodized finish
2 Vertical aluminium cladding extrusion, natural anodized finish
3 Pressed aluminium cloak at junction of horizontal and vertical extrusions
4 Stainless steel self tapping screw fixing with metal and neoprene composite washer, fixed through pre-drilled holes in cladding panel
5 Super plastic aluminium formed cladding panel, metallic grey Duranar PVF2 finish on 1 x 2m overall grid
6 Pressed aluminium fascia with concealed ventilation slots; finish and fixings as for panels
7 Pressed aluminium cavity tray
8 Compriband V-seal compressed form weather-tight joint
9 Insulated fire wall lining system, mechanically fixed
10 229 x 89mm RSC channel cladding rail
11 Reinforced concrete ground slab

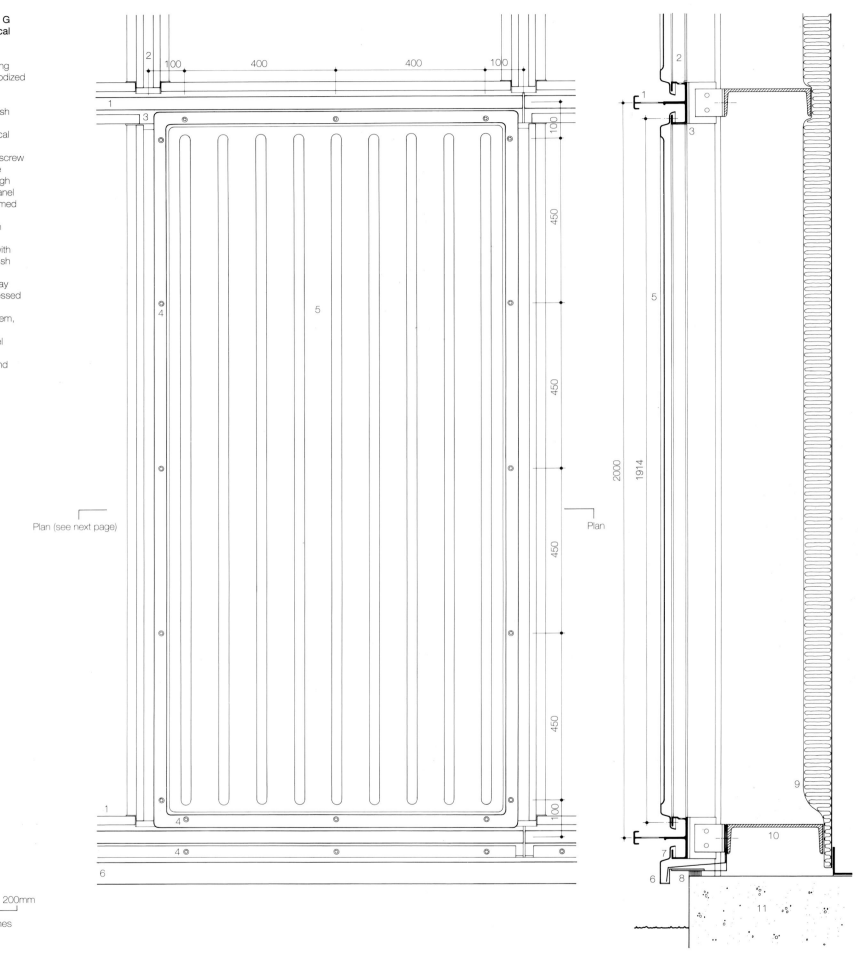

Plan (see next page)

Plan

0 200mm

0 6 inches

0 100mm

0 4 inches

Detail H showing panel fixing
Scale 1:4

Plan section through typical panel assembly at column condition
Scale 1:10 and detail 1:4
1 610 x 305mm UC columns at 6m centres
2 Vicuclad fire protective cladding
3 Pressed metal closer
4 Fire-proof compressible filler strip
5 Insulated firewall lining system
6 229 x 89mm RSC horizontal channel cladding rail with 30mm long slotted holes for rail expansion; M10 bolt fixings to cleats
7 Aluminium fixing brackets
8 Vertical aluminium cladding extrusion, natural anodized finish
9 Horizontal aluminium cladding extrusion, natural anodized finish; nominal length 3m
10 Super-plastic aluminium formed

cladding panel, metallic grey Duranar PVF2 finish, on 1 x 2m overall grid
11 50mm diameter slotted drainage holes at 200mm centres
12 Stainless steel self-tapping screw fixings with metal and neoprene composite washer, fixed through pre-drilled holes in cladding panel
13 3mm thick x 20mm wide butyl sealing strip around perimeter of panel
14 Neoprene isolating pad between aluminium angle and column

0 200mm

0 6 inches

Detail H

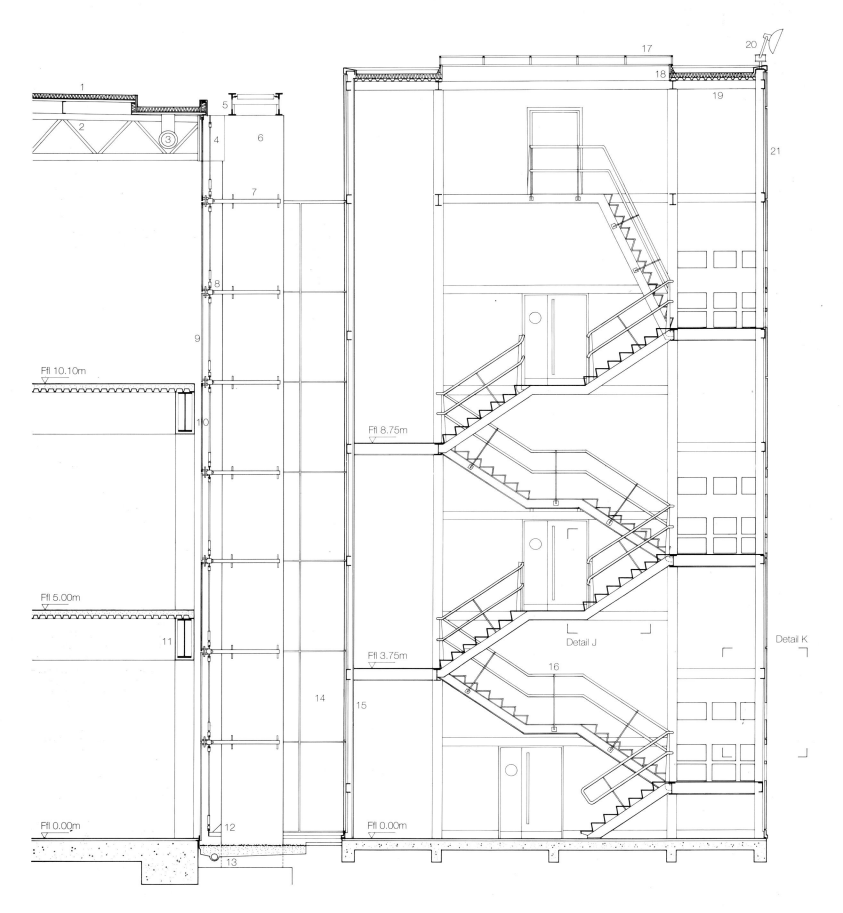

Section through central stair tower and southern glazed wall

Scale 1:80

1 Roof build up: single layer Trocal PVC membrane; 80mm Rockwool roof decking slabs; high performance polythene vapour barrier; 35mm deep 0.75mm thick profiled steel decking on purlins at 1500mm centres

2 Roof truss

3 Cast iron rain-water outfall pipe

4 18mm diameter Macalloy suspension rod

5 457 x 152mm UB beams with 230mm diameter holes at 500mm centres

6 Fabricated steel aerofoil column

7 Fabricated steel wind-restraint glazing arm

8 Typical fixing bracket assembly

9 12mm thick solar tinted toughened glass panel on 2 x 2m overall grid

10 12mm thick black emulsified toughened glass panel on 2 x 2m overall grid

11 Fire-protected structural steelwork supporting intermediate accommodation floors

12 Typical suspension rod base plate assembly

13 French drain with gravel in drainage channel

14 Flat aluminium cladding panel, coil coated metallic silver PVF2 finish, on 1 x 2m overall grid

15 Gypglas fire-protective lining system, curved to profile of stair tower adjacent to glazed wall

16 Fabricated steel staircase and balustrade

17 Single glazed polycarbonate rooflight with splayed upstand and ventilated ends

18 203 x 133 UB roof beam

19 203 x 89mm RSC channel perimeter beams

20 Floodlight fixed to bracket mounted on 203 x 89mm RSC capping steelwork

21 Pressed aluminium cladding panel, coil-coated metallic silver PVF2 finish; polycarbonate glazed inserts at landing levels

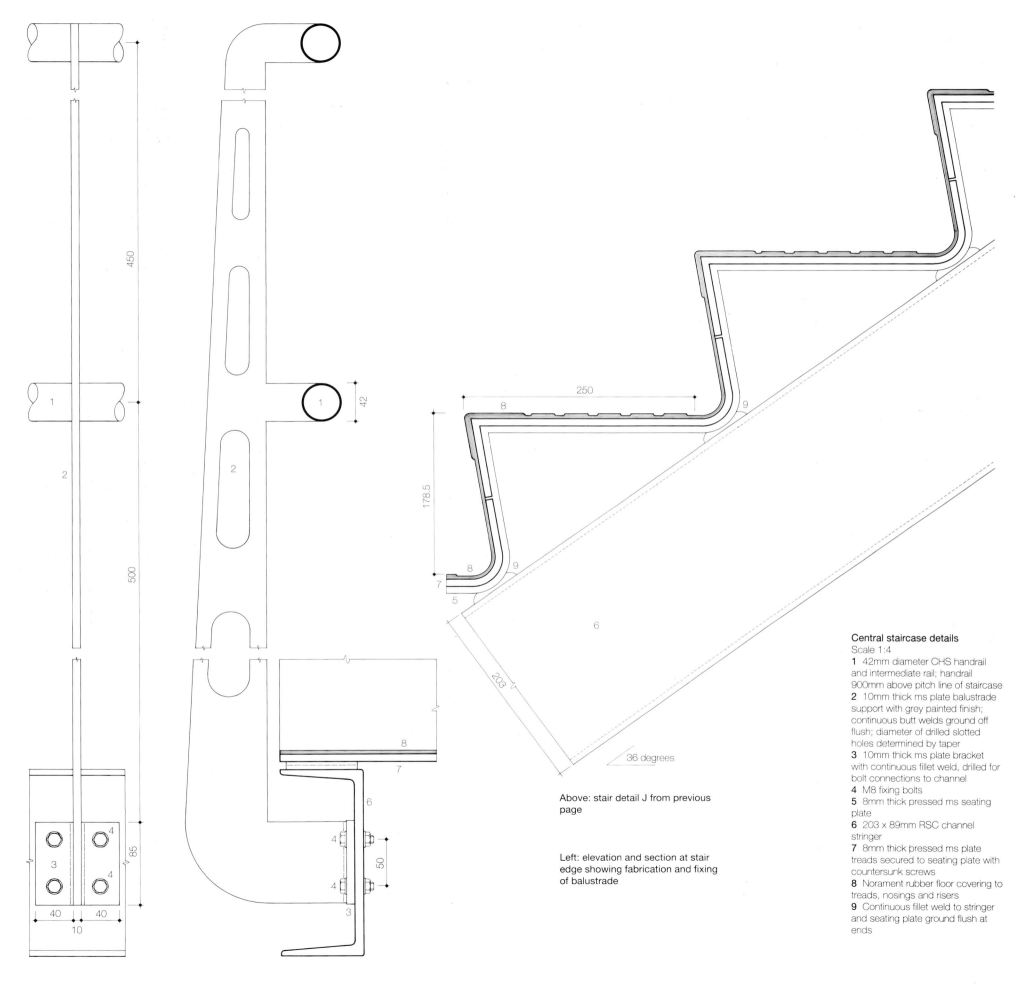

450

1

2

500

1

3

4

4

4

85

40

40

10

2

1

42

2

178.5

203

8

250

9

8

9

7

5

6

36 degrees

8

7

4

4

50

6

3

Above: stair detail J from previous page

Left: elevation and section at stair edge showing fabrication and fixing of balustrade

Central staircase details
Scale 1:4
1 42mm diameter CHS handrail and intermediate rail; handrail 900mm above pitch line of staircase
2 10mm thick ms plate balustrade support with grey painted finish; continuous butt welds ground off flush; diameter of drilled slotted holes determined by taper
3 10mm thick ms plate bracket with continuous fillet weld, drilled for bolt connections to channel
4 M8 fixing bolts
5 8mm thick pressed ms seating plate
6 203 x 89mm RSC channel stringer
7 8mm thick pressed ms plate treads secured to seating plate with countersunk screws
8 Norament rubber floor covering to treads, nosings and risers
9 Continuous fillet weld to stringer and seating plate ground flush at ends

0 1000mm

0 4 inches

Details of curved cladding panels to central staircase tower

Scale 1:20 and 1:2

1 Makrolon long-life scratch resistant polycarbonate sheet window, cold formed to radius of curved cladding panel

2 Black silicone seal

3 50mm wide aluminium frame, natural anodized finish, with neoprene weatherproof seals

4 Stainless steel self-tapping screw fixings with metal and neoprene composite washers, fixed through pre-drilled holes in cladding panel

5 Vertical extruded aluminium cladding rail, natural anodized finish

6 Pressed aluminium cladding panel, coil coated metallic silver PVF2 finish

7 Insulated inner lining tray to panel, coil coated metallic silver PVF2 finish

8 Insulated inner panel, metallic silver PVF2 finish

9 Extruded aluminium horizontal cladding rail, natural anodized finish, fixed to span between vertical cladding rails

10 Continuous aluminium drip over window formed to radius of panel, natural anodized finish

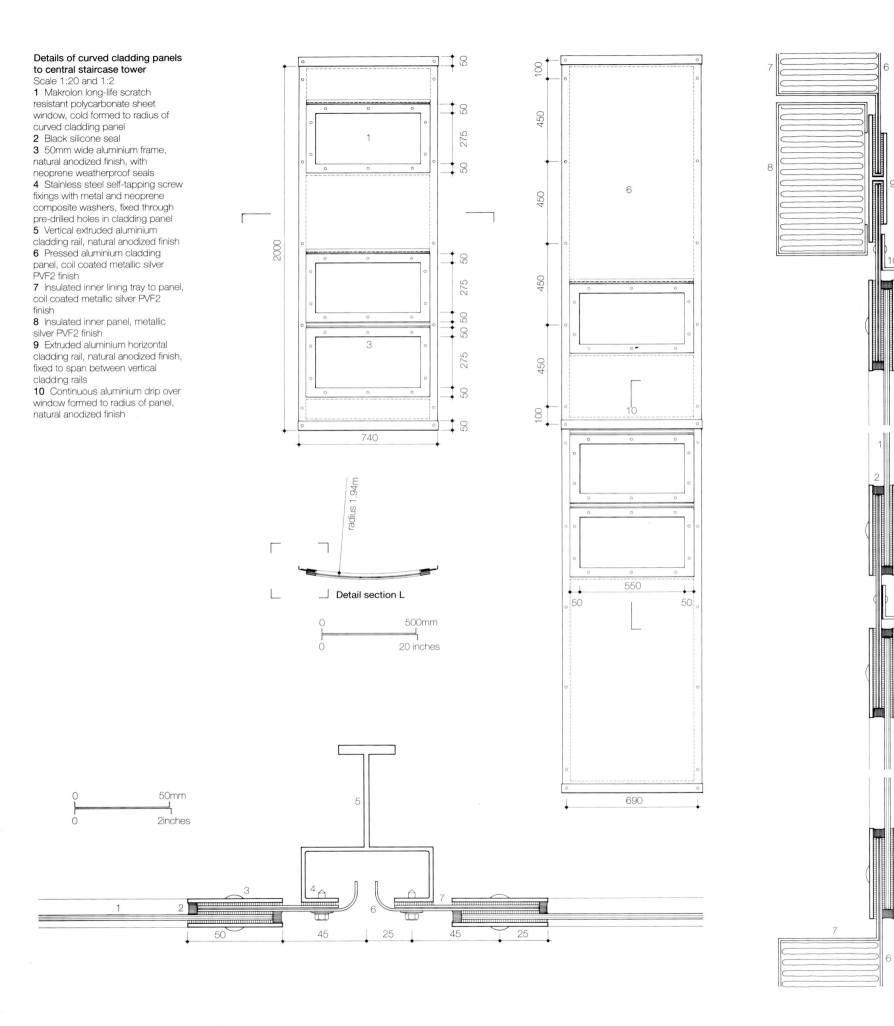

Detail section L

radius 1.94m

0 ————— 500mm
0 ————— 20 inches

0 ————— 50mm
0 ————— 2inches

Chronology, awards and commendations, published articles

November 1986 Nicholas Grimshaw and Partners appointed by FT
December 1986 Scheme approved by LDDC
February 1987 Site clearance by LDDC commenced
March 1987 Management Contractor appointed
April 1987 Piling commenced
December 1987 Building envelope completed
January–June 1988 Installation of presses and building fitting-out period
July–September 1988 Three-month press commissioning period
September 1988 Full print production of FT begins

Awards and commendations

RIBA Architecture Awards 1989: Regional Award, National Award
Royal Fine Art Commission/ Sunday Times Building of the Year Award: joint winner
Civic Trust Award 1989
Illustrated London News 1989 London Awards: Award, Development category
Constructa Prize 90 – European Award Program for Industrial Architecture: second prize
Building and Construction Industry Awards 1989: High Commendation
Structural Steel Design Awards 1989: Commendation

Published articles

AJ Focus – 'Maximum Vision', October 1988
Architectural Review – 'Glass wall in Blackwall', November 1988
Blueprint – 'A Sign of the Times', November 1988
Business – 'Press Revelation', November 1988
New Civil Engineer – 'Drama on a Tight String', 1 December 1988
Progressive Architecture – 'Selected Details', December 1988
Archi-Cree, December 1988/ January 1989
De Architect Thema, May 1989
Baumeister, July 1989
New Civil Engineer – 'Inner Vision', 26 October 1989
RIBA Journal – 'RIBA Awards for Architecture', January 1990
L'Architecture d'Aujourd'hui, February 1990

**Architects, consultants,
contractors and suppliers**

Location: East India Dock Road,
London E14
Client: Financial Times/St Clement's
Press
Architect: Nicholas Grimshaw and
Partners
Design Team: Paul Grayshon, Nick
Grimshaw, Rosemary Latter,
Frank Ling, Christopher Nash,
Wolfgang Zimmer
Structural Engineers: J. Robinson &
Sons
Press Engineers/Interior
Consultants: Robinson Design
Partnership
Services Engineers: Cundall
Johnston & Partners
Quantity Surveyors: Smerdon &
Jones
Management Contractors: Bovis
Construction Ltd

Subcontractors

Piling: Cementation. Ground-
works/concrete: Tarmac. Aerofoil
column fabrication: Fairfield Mabey.
Structural steelwork: Conder
Structures. Secondary steelwork:
R.C. Jenkins & Son (Construction)
Ltd. Cladding: BACO Contracts
Ltd. Glazing: Pilkington Glass Ltd.
Roofing and plantroom cladding:
SIAC Construction Ltd. Builders'
work: Ashby & Horner Ltd. External
works: O'Keefe Construction Ltd.
Illuminated sign: Pearce Signs
(Kent) Ltd. Lifts: Keighley Lifts Ltd.
Press assembly: Rockwell Beck &
Pollitzer.

Suppliers

Superform cladding panels and
louvre panel surrounds: Superform
Metals Ltd. Paint finish to cladding
panels: PPG Industries Ltd. Flat
cladding panels and duct access
panels: BACO Contracts Ltd.
Extrusions: British Alcan Extrusions.
Panel sealing tape: Corofill Cold
Rolled Products. Louvre panel
inserts: Airstream Environmental
Services. Personnel doors:
Norwood Partitions. Ironmongery:
Elementer Industrial Design Ltd.

Industrial loading doors: R.S.
Stokvis & Sons Ltd. Firewall lin
system: Condor Structures. Insu
lation: Rockwool Ltd. Fire protect
to columns: Morceau. Fire stoppin
Corofil Cold Rolled Products. Roof
decking: SAB Profiel. Roof water-
proofing system: Buildex. Smoke
vents: Colt International Ltd. Spine
plant room copings: Alfab Ltd. Paint
finish to aerofoil columns: Herberts.
Central tower glass door assembly:
Pilkington Glass Ltd. Door patch fit-
tings and floor springs: Dorma Door
Controls Ltd. Stairtower rooflights:
William Cox Ltd. Polycarbonate stair
tower windows: Roehm Ltd. Fire
protection paint systems: Nullifire
Ltd. Dry riser inlet and outlet boxes:
Dunford Fire Engineering. Rubber
floor finish and skirtings: Carl
Freudenberg & Co. (UK) Ltd. Black
granite: Quiligotti & Co. Ltd. Track
and light fittings to central tower:
Concord Lighting Ltd. Emergency
lights: Marlin Lighting Ltd. Flood
lights: Philips Electronics. Hexag-
onal block paving: Marshalls Mono.
Block paving and manhole covers:
Frederick Jones & Son (Oswestry)
Ltd. Bollards: Townscape Products
Ltd. Flagpoles: Ian Proctor Metal
Masts Ltd. Railings and access
gates: Argosy Fence Supplies Ltd.